Chinese Classical Furniture

TITLES IN THE SERIES

Series Editors, China Titles:
NIGEL CAMERON, SYLVIA FRASER-LU

Chinese Classical Furniture

GRACE WU BRUCE

HONG KONG
OXFORD UNIVERSITY PRESS
OXFORD NEW YORK
1995

Oxford University Press

Oxford New York
Athens Auckland Bangkok Bogotá
Buenos Aires Calcutta Cape Town Chennai Dar es Salaam
Delhi Florence Hong Kong Istanbul Karachi
Kuala Lumpur Madrid Melbourne Mexico City Mumbai
Nairobi Paris São Paulo Singapore Taipei
Tokyo Toronto Warsaw

and associated companies in
Berlin Ibadan

Oxford is a registered trade mark of Oxford University Press

Published in the United States
by Oxford University Press Inc., New York

First published 1995
Second impression 1998

© Oxford University Press 1995

British Library Cataloguing in Publication Data
available

Library of Congress Cataloging-in-Publication Data
Wu Bruce, Grace, date.
Chinese classical furniture / Grace Wu Bruce.
p. cm. — (Images of Asia)
Includes bibliographical references and index.
ISBN 0-19-585818-2
1. Furniture — China — Ming–Ch'ing dynasties, 1368-1912. I. Title.
II. Series.
NK2668.W8 1995 95-12654
749.2951 — dc20 CIP

Printed in Hong Kong
Published by Oxford University Press (China) Ltd
18/F Warwick House, Taikoo Place, 979 King's Road,
Quarry Bay, Hong Kong

Contents

To Antonia

May her interest in things Chinese grow
with age

1
History and Development of Chinese Furniture

Extensive archaeological works undertaken in China during the past four to five decades have provided fresh glimpses into the life and culture of its people throughout its long history, as well as insights into the evolution of its furniture. The earliest excavated pieces of furniture were found in tombs dated to the Chu Kingdom, of the late Warring States period (475–221 BC). Life in China at this time was conducted at the 'mat level': people knelt, then sat on their heels on mats placed on the ground. The furniture in use at this time was low and complemented a lifestyle where people ate, slept, worked, and played at ground level.

Furniture pieces excavated from Chu tombs are generally made of wood and were often decorated with painted or carved lacquer. They usually have a black ground contrasting with red or polychrome designs of gold, silver, yellow, brown, green, red, grey, or blue. Bronze corners and masks of animals with rings in their mouths were used as decorations, and the application of inlaid jade stones had already made its appearance. Differing types of mortise and tenon joints were in use, as well as hinge mechanisms which both allowed for pieces with covers or doors to be opened and closed and for different parts of the same piece of furniture to be folded away. Other materials used on the furniture included bamboo, silk, and mats.

Two beds dated to the fourth to third century BC amply demonstrate how sophisticated in both design and construction Chinese furniture was at the time. The first of

these two beds was excavated from Xinyang, Henan province, in 1957 and the second in 1987 from Baoshan, Jingmen, Hubei province. Both beds are over 2 metres long and about 1.4 metres deep, and each is comprised of three parts: the bed frame with transverse braces supporting a seat of mat, bamboo, or wood; the feet; and the railings. The Xinyang bed (Fig. 1.1) has a black lacquered frame decorated with a red angular scroll design, and six stout legs powerfully

1.1 Bed frame excavated at Xinyang, Henan province, 4th to 3rd century BC.

carved in double scrolls or coiled creatures. These legs are lacquered and are fitted to the bed frame by mortise and tenon joinery. The railings are made of small bamboo poles wound with silk and have metal fittings. The Baoshan bed (Fig. 1.2) also has a mortised and tenoned bed frame with low railings of geometric design made of wood and bamboo strips. The design of the feet closely follows that of the railings, and the entire piece is lacquered black. The seat of the bed has three layers, the bottom made of polished bamboo strips which have been covered with matting and then silk waddings. By using a system of mortise and tenon, lap joints, and hinge mechanisms, the bed can be folded away.

1.2 Folding bed excavated at Baoshan, Hubei province, 4th to 3rd century BC (source: *China Pictorial*, 1988).

Other types of Chu furniture that have come to light are armrests, small low stands one could lean on while seated, low tables to hold food and drink, and clothes chests and boxes for the storage of wine vessels, food utensils, and also tools.

It is known that screens were used during the Chu period. It was recorded in the ancient text *Zhou li* that screens were made of thin silk and placed behind the emperor when he gave audience. The *Zhou li* also notes that screens provided protection from the wind, a more likely reason for their original conception than the function to indicate a place of honour. A small and impressive lacquer screen (Plate 1) was excavated in 1965 from the number 1 Chu tomb at Wangshan, Jiangling, Hubei province. Its base, carved with coiling snakes in high relief, has two ends that rest on the ground and a raised middle section. The frame of the screen is rectangular, enclosing exquisite openwork carving of 51 different kinds of animals, both mythological and taken from nature. There are snakes, frogs, deer,

phoenixes, and birds. The whole piece is lacquered black and then vividly decorated with red, grey-green, gold, and silver painted patterns. The superb and realistic carving of the animals creates a lively scene, truly a magnificent work of art, perhaps surpassing the finest furniture made by any other ancient civilization.

Archaeological evidence shows that the next four to five hundred years saw little change in the development of furniture, as the custom of kneeling and sitting on mats continued. These mats were square or rectangular, and they were made of rush or bamboo, sometimes bound with coloured threads and often bordered with fabrics or silk. Some were large enough to seat four people while others could only seat one.

The engraved stone image (Fig. 1.3) on the wall of the early third-century AD Han dynasty tomb at Mixian, Henan province, may be a typical banquet scene of the time. It depicts a canopy with tassles. Below this stands a smaller

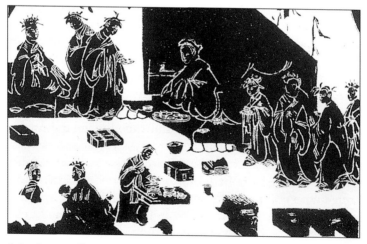

1.3 Stone wall carving of banquet scene, Mixian, Henan province, Han dynasty, early 3rd century AD (source: *Wenwu*, 1972).

canopy, underneath which sits what appears to be the host, probably the occupant of the tomb. Before him is a large low table with cups and plates. On the left, a guest kneels on a mat with a low table in front for cups. Two other guests, also kneeling on mats, converse in the foreground. Other well-attired standing figures are depicted holding drinking vessels or plates while a servant attends to the utensils.

At about the same time as the Han stone carvings, the term *ta* appeared in texts. *Ta* indicated a type of low platform-like seat, usually used for sitting but sometimes large enough to sleep on. The Mixian tomb banquet host appears to be sitting on such a low platform.

During the Jin dynasty (AD 265–420), the Southern and Northern dynasties (420–589), and into the Tang dynasty (618–907), the long-established custom of kneeling and sitting on one's heels gradually gave way to more comfortable postures including sitting cross-legged, leaning sideways with legs outstretched, and finally sitting straight up on higher seats with legs extended to the floor as we do today. With the relaxed etiquette for sitting came new forms of furniture, such as waisted round stools, square stools, and folding stools. Traditional low furniture associated with the mats was adapted to the higher seats.

It should be mentioned here that a type of seat called *huchuang*, or 'barbarian bed', was already known during the Western Han (206 BC–AD 9), although it was not widely used until much later. The *huchuang* is a folding stool with the back and front legs hinged where they cross, and horizonal stretchers, threaded with rope, connecting the legs to serve as a seat. The character *hu* referred to the minority group in China's north where these stools may have originated. The *chuang* or 'bed' here is used in its meaning as a seat form.

The period during which people moved from mats to chairs was an important one in the evolution of Chinese furniture. However, no actual example of furniture from this period has yet come to light and even documentary evidence is scanty. Fortunately, the frescoes and sculptures in the Mogao caves at Dunhuang, Gansu province, offer valuable images of furniture used during this period. Out of nearly 500 caves, two-thirds date from the Sixteen Kingdoms period of the Northern Dynasties to the Sui (581–618), Tang, and the Five Dynasties (907–960). The images with furniture indicate a gradual movement from low pieces associated with the mat culture to higher ones. New types of seats like stools appeared, and in banquet scenes people are depicted sitting on four-legged benches around long rectangular tables. High folding screens and eventually chairs were seen. It would appear that during the fifth and sixth centuries, the Chinese began to construct higher furniture, and the trend continued in the Tang and Five Dynasties, making these eras the change-over period between low and high furniture.

Many types of high furniture are seen in paintings of this period. In the much-published handscroll *The Night Banquet of Han Xizai*, attributed to the tenth-century artist Gu Hongzhong and now in the Palace Museum, Beijing, there are five colourful scenes depicting merrymaking. Han Xizai and his guests are entertained by female musicians and dancers while serving girls bring wine in ewers to tables laid for a feast. Many types of furniture are illustrated: stools, chairs, footrests, tables, beds, couch-beds, screens, clothes racks, various types of drum stands, and lamp stands.

By the Song dynasty (960–1279), high furniture was widely accepted and adopted by all echelons of society. The types of furniture available were quite varied and the designs fully realized. Continuous development and refinement over

the next few hundred years led to a period in the late Ming (1368–1644) when China's furniture reached the height of its development and entered its golden period.

Many factors contributed to the flowering of China's furniture tradition in this particular period. During the reign of the early Ming emperors, artisans living in or near the capital were required to report for work in the palace workshop for 10 days each month, while those from other parts of the country worked three months every three years, mainly for the imperial Board of Works. In the mid-fifteenth century, the requirement that artisans report for duty was relaxed and by late in that century, it became a custom to commute the service period into a payment in silver. By the sixteenth century all artisans paid the tax rather than serving. This improvement in working conditions led to more people becoming artisans, swelling the ranks of carpenters and cabinet-makers.

Other policies adopted in the early Ming were successful in improving agricultural production. The amount of land under cultivation increased by almost five times from 1368 to 1393. The population also increased. Large advances were made in many areas including the production of silk, textiles, and ceramics, the smelting of iron ores, and ship-building. Commercial activities blossomed, causing unprecedented expansions in cities and towns as well as the mushrooming of new centres for commerce. During the fourth year of the reign of the Xuande Emperor (r. 1425–35), 33 cities along the Yangtze River and the north–south canal set up *chaoguan*, organizations to collect taxes associated with commercial activities. By mid-Ming, many small towns in the Jiangnan area, the provinces of Anhui, Jiangsu, and Zhejiang, grew into important cities with the prospering of the silk and textile industries, and by the time of the Jiajing, Longqing, and Wanli emperors (1521–1620), the pop-

ulation and trade in these parts had increased by up to ten times. The citizens of this prosperous China greatly increased their demand for luxury products including fine furniture, thus providing fresh impetus for its development.

During the reign of the Longqing Emperor (r. 1567–72), the ban on maritime trade was lifted, with the effect of stimulating more trade and bringing more prosperity to the coastal provinces. One of the side effects was that vast quantities of fine tropical hardwood timber were imported from South-east Asia, providing the cabinet-makers with excellent materials to ply their craft, and the resultant products surpassed their predecessors.

The eminent Beijing art historian Wang Shixiang was the first to identify these socio-economic circumstances which contributed to the golden era of China's furniture-making. He concluded that from the mid-sixteenth century, furniture-making reached new heights in terms of design, craftsmanship, and material used. The craftsmen's products were not only functional but were objects of beauty having great artistic value.

Furniture made during the early Qing dynasty (1644–1911) closely followed the Ming style. During the reign of the Kangxi Emperor (r. 1662–1723) changes were made partly due to the literati involvement in new furniture design for both the court and their peers. By the time of the Qianlong Emperor (r. 1736–96), the spirit and style of furniture had changed drastically. While it was made of excellent material and finely crafted, it was often decorated with overly ornate carvings, and by the late Qing, furniture-making had deteriorated to such an extent that the outcome was only suitable for utilitarian functions in the civilized world.

2
Ming Dynasty Furniture

The study had one main room and two side chambers. . . . As they entered the main room . . . Bojue saw six low *dongpo* folding chairs, inlaid with agate from Yunan, decorated with golden nails and with rattan mat seats arranged in two lines; four scrolls of landscape paintings by well-known artists mounted on sky-blue patterned silk edged with a white silk border were hung on each side of the walls; [below these stood] on each side a small table with Dali marble top and cabriole legs bearing an ancient bronze censer and gilded crane. . . . Bojue went into the east chamber, [where] a gold inlaid black lacquer canopied bed with Dali marble panels was placed on the low floor platform . . . [On] two sides [were] a pair of gold painted polychrome lacquer bookcases . . . and below the green translucent curtains by the window was a black lacquer lute table with a single mother-of-pearl inlaid folding chair . . .

The Golden Lotus, chapter 30

This passage from a sixteenth-century novel by an anonymous author, with its vivid description of the furniture of the time, is but one of many in the popular novels of the late Ming. These novels offer us a glimpse of the lifestyle of the period and provide valuable information about what types of furniture were in use. *The Golden Lotus* (Jin ping mei), with its one hundred chapters, is perhaps the most descriptive and revealing of all. The story's chief protagonist, Ximen Qing, owns an herbal medicine shop, and in the social hierarchy of the late Ming he belongs to the lowest merchant class. Through bribery of various officials, he purchases for himself a minor post and overnight becomes

a 'scholar–official'. In keeping with his new-found status, he acquires a study (literally a 'book-room' when translated from the Chinese *shufang*). Instead of books, however, he has installed in it the most lavish furnishings. Through the eyes of his friend Ying Bojue, we can see the types of furniture that the *nouveau riche* Ximen considers status boosters: lacquer furniture of gold painted polychrome, black with gold inlay and plain black lacquer pieces, and luxurious chairs and beds with gold bosses and inlaid with agate, mother-of-pearl, as well as Dali marble panels.

However, entirely different types of furniture seem to have been considered *de rigueur* by the élite scholars of the time. *Suibi*, the term used for their writings, can be translated loosely as 'guides to elegant living'. In late Ming society, scholars ranked the highest amongst all classes of people, and their leaders were talented in the arts, poetry, calligraphy, and other refined pursuits associated with elegant living. In their language, *ya*, 'refined', is the ultimate praise while *su*, 'vulgar', carries the utmost condemnation. Those scholars whose opinions were influential in determining the *ya* and *su* way of living were themselves men of wealth and position and were also often of impressive lineage. It was their desire to distinguish themselves from the *su* officials and *nouveau riche* merchants that motivated them to write these *suibi*.

Of all the *suibi*, the most informative in terms of furniture is *Zhangwu zhi* (Treatise on superfluous things), written by Wen Zhenheng around 1620. Wen described twenty types of furniture of various materials and expounded on his, and what must have represented the upper class's, attitude toward furniture. Leaving aside the value and aesthetic judgement coloured by his circumstances, these passages provide invaluable information as to the furniture available during the late Ming.

An example from Wen's *Zhangwu zhi* is a discussion of the merits of different chairs:

[The] *chanyi*, [a] meditation chair made of rattan from Zhejiang or old gnarled tree root[:] . . . Chair designs are numerous, a Yuan dynasty mother-of-pearl inlaid piece seen was big enough to seat two. . . . The ones made in *wumu* [ebony] with Dali marble panels [are] the most expensive. . . . The bamboo chairs from Wujiang (Jiangsu province) . . . are too vulgar to contemplate using . . .

Differences over merit are seen between the popular novels and the *suibi*, and between the *suibi* and official sources. While some bamboo chairs were considered vulgar by the upper classes, illustrations in the *Sancai Tuhui*, the Ming pictorial encyclopedia published in 1607, indicate spotted bamboo chairs and stools were one of the main types of furniture (Fig. 2.1). These conflicting tastes and preferences in different segments of society, or perhaps even in different camps of the same class, were again manifested in the

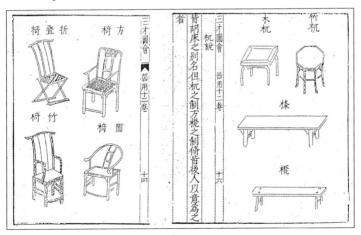

2.1 Chairs and stools of the Ming dynasty, pictured in the *Sancai Tuhui* (source: Wang 1958, vol. 2).

entry in the *Sancai Tuhui* on ceremonial chairs used at court (Fig. 2.2):

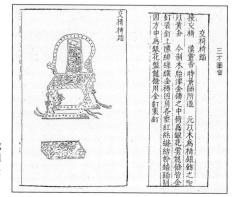

2.2 Gold lacquered folding chair and footrest, pictured in the *Sancai Tuhui* (source: Wang 1958, vol. 3).

[A] folding chair and footrest, . . . the present standard is made of wood and painted gold, the central back support decorated with patterns of clouds and dragons in silver and gold, the rest ornamented with golden nails . . .

It would seem these same ones were considered vulgar by the scholarly Wen Zhenheng:

Folding chairs after the traditional design *huchuang* have silver inlaid legs and silver hinges . . . and are most suitable for travelling in the mountains or using on boats. The gold lacquer ones are *su* and not to be used . . .

The passage in *Zhangwu zhi* on beds also saw Ximen Qing's prized polychrome lacquer pieces condemned:

The small lacquered Song and Yuan dynasty beds are the best, the next being the single beds [made after the style] of the palace while after that the small wooden pieces made by fine craftsmen If the bamboo beds, canopied beds and beds with antechambers are polychrome lacquer or geometric designs etc., they are *su*. . . .

This negative assessment did not reflect the market values assigned to the beds of the corrupt premier Yan Song, whose demise in 1565 resulted in the confiscation of his entire estate. The inventory comprised a total of 389 Dali marble and gold lacquer screens; 657 Dali marble, inlaid mother-of-pearl, lacquer, and other beds; and tables, chairs, cabinets, benches, stools, stands, shelves, and footrests, amounting to 7,444 pieces! Among the beds, 17 particularly fine ones were annexed by the imperial household, 15 of which were specified as being made of carved, inlaid, or incised lacquer. Cash values were assigned to the balance, with lacquered beds with antechambers heading the list, each valued at 15 *liang* of silver. A single bed of *ju* (zelkova) was five *liang*, and 40 beds of plain lacquer or *huali* (tropical hardwood) were valued at one *liang* each.

This assessment would seem to contradict Wen's 1620 proclamation that exalted first antique beds, followed by the palace-style beds, although what this latter type was made of is unclear. Plain wooden pieces made by fine craftsmen came third and were certainly placed above those of painted polychrome lacquer. Whether this is a 'scholarly class' preference or whether, in the fifty years or so between the Yan inventory list and Wen's writings, hardwood furniture had reached a new status due to its development has yet to be explored.

There is good reason, however, for the presumption of such a dramatic development, as by the late sixteenth century references were made to the fact that *jumu* furniture was not as expensive as that of *huali*, contrary to the valuation in the Yan list. Of course this does not preclude the obvious preference some influential members of the scholarly class had for some types of wooden furniture, as seen in the direct references to their desirability in Wen's treatise.

Tianranji [naturalistic tables or stands] use well-figured wood like *huali*, *tieli*, and *xiangnan* for their manufacture. . . . [For] couch-beds, . . . antique lacquered pieces and Yuan mother-of-pearl inlaid pieces are naturally *ya*. . . . Recently there are those with inset Dali marble, red or black lacquer with a faded finish, . . . those of new inlaid mother-of-pearl, all are vulgar; others made of well-figured *nan*, *zitan*, *wumu*, and *huali* in traditional designs are desirable. . . .

These sources reveal a furniture world various in types and rich in the materials used. The interiors of mansions in the late Ming could be decorated with opulent carved lacquer, inlaid mother-of-pearl, agate, Dali marble, and gold. Gold lacquer, gold nails, gold-filled polychrome lacquer or the more 'scholarly and refined' arrangements of plain, often black lacquer pieces, bamboo, rattan furniture, and pieces made of various woods, including tropical hardwoods with rich warm colours and sometimes well-figured patterns, were also used.

It would seem certain that various combinations of furniture were in use in the large households, but the proportions of the various types can only be guessed at. It stands to reason however that pieces like the carved lacquer table of the Xuande period shown in Plate 2 would have been rare in any household. To build up the hundreds of layers of lacquer, each of which needed to dry before the next could be applied, would mean that it took years to make such a piece of furniture. The Yan Song inventory confirms this; out of almost 700 beds, only 15 were made in the various intricate techniques of lacquer, and this was in a household whose material possessions were perhaps second only to those of the emperor. Today only several dozen or so examples of Ming carved, incised, and inlaid lacquered furniture are known to have survived in China and around the world.

Of the other types of luxurious furniture, like pieces inlaid with mother-of-pearl, agate, and gold nails, we have few surviving examples, perhaps because their softwood skeletons could not withstand the ravages of time, war, and destruction. Of the plainly lacquered pieces of black, brown, or red, almost none have survived, again presumably because of their fragility. Old furniture made of bamboo and rattan exists but none can be dated convincingly to the Ming. The same applies to root furniture, except for those few pieces which had been inscribed by their users through the years.

Does this mean that we are left with nothing from the golden age of China's furniture manufacturing period? Not at all. Fortuitously a large body of exceptional furniture from this period has survived, those pieces made from dense tropical hardwoods varying in colour from jet-black, to purple-brown, to the many shades of browns from rich mahogany to a light honey, and those that have been constructed in a manner that enabled them to withstand the test of time. Many examples are in pristine condition despite over three to four hundred years of constant use; these have designs which appear simultaneously timeless and modern. These groups of examples have survived in quantity, to be hailed as the archetypes of China's classical furniture, known in the twentieth century simply as Ming furniture.

Hardwood furniture was important in the late Ming and would seem to have risen to that position sometime after the Yan Song inventory in 1565. We have little information as to the circumstances of its rise in popularity among consumers, but we know for certain that some time during the second half of the sixteenth century it was sought after and had become something of a status symbol in the prosperous area of Jiangnan.

In my youth [around 1560], I hardly saw any good quality furniture like desks or large chairs made of fine woods. People used gingko wood square tables lacquered in gold. Mo Tinghan and the sons of the Gu and Song families began to buy a few fine pieces of hardwood furniture from Suzhou. Since the Longqing and Wanli [1572–1620] periods, even minor officials used these wooden pieces in their homes. The small cabinet-makers from Huizhou [Anhui province] rushed to Yunjian [near Suzhou] to set up shops selling dowry furniture and miscellaneous pieces. The wealthy families would not use *jumu* furniture as it was not expensive enough; all beds, cabinets, stands, and tables must be made of [fine woods like] *huali*, *yingmu* [burlwood], *wumu*, *xiangsimu* [chicken-wing wood] and *huangyangmu* [boxwood]. It became fashionable to spend thousands of taels of silver on a single piece. Even the *yamen* [government office] runners install a 'study' with partitions in their houses placing goldfish bowls and flowerpots in the courtyard while inside would be a fine wood desk complete with fly whisk; I wonder what books these runners study.

This important reference to the development of wooden furniture, from *Yunjian Jumuchao* (Records of events in Yunjian) by Fan Lian (b. 1540), was discovered by Wang Shixiang. Wang found another late Ming source describing wooden furniture, *Guang zhi yi* (Records on a wide variety of topics) by Wang Shixing, of the Ming dynasty:

The citizens of Suzhou are intellectual, clever and appreciate the ways of old. They are also adept at copying the old methods. . . . Lately the fashion is to have the table objects for amusement in a scholar's studio, stands, tables, beds, and couches made out of *zitan* and *huali*. The simple forms are preferred to the ones with carving. When pieces are carved, they follow the old motifs of the Shang, Zhou, Qin, and Han [dynasties]. [Craftsmen] near and far all copy their work. This fashion was widespread during the reigns of the Jiajing, Longqing, and Wanli emperors.

These two references are highly important in that they tell us the late sixteenth to early seventeenth century was the period when fine wooden furniture was extremely fashionable. All sorts of furniture—chairs, tables, beds, cabinets, scholars' objects, dowry furniture, and even miscellaneous housewares—were fashioned out of fine woods, and they were both plain and carved. They were expensive and were used by all echelons of society, and Suzhou was an important centre for their manufacture (although by no means the only one). We know that other centres included Huizhou and that the furniture-makers brought their works to Suzhou for sale.

Other references point to the existence of workshops in the provinces Zhejiang and Jiangsu. The city of Yangzhou in Jiangsu was singled out as the best production centre for wooden articles by Li Yu, the seventeenth-century dramatist known also for his doctrines on garden and interior designs. In his *Li Liweng yijiayan quanji* (The Words of one master), the section on chairs and stools says 'those made now are superior to the old ones and the workmanship better in the south than the north. The wooden products of Yangzhou and the bamboo ware of Suzhou are the best in the country and in all history.'

It would seem that fine wooden furniture was made in a number of cities in the lower Yangtze River valley in south-central China, an area which was also the most populous and affluent part of China at that time. It was also made in the *Yu yong jian*, the palace workshop in Beijing. The eunuch at Wanli's court, Liu Ruoyu, wrote in *Zhuo zhong zhi* (Record of life in the administrations), listing the functions of the *Yu yong jian* as 'to produce for imperial usage screens, objects for decorations, utensils, . . . hardwood beds, tables, cabinets, display shelves and [objects made from] ivory, [fine woods like] *huali, baitan, zitan,*

wumu, jichimu, shuanglu ['double-six' game boards], chess
boards, games pieces, combs, cages, [pieces made of] mother-
of-pearl inlaid, carved and filled-in lacquer, carved lacquer,
trays and boxes, fan handles and others. . . .'

So far no signed piece of Ming furniture made from fine
wood has surfaced to give us clues as to the identity of
their makers or their workshops, and perhaps no such piece
exists. No records or manuals of individual cabinet-makers
have survived from the period (those that have postdate
the Ming furniture era and were records kept in the palace
workshop), again perhaps none existed, as traditionally cab-
inet-makers have learned their craft orally from their mas-
ters. We have, however, the fascinating *Lu Ban jing jiangjia
jing* (The Classic of Lu Ban and the craftsmen's mirror),
named after the mythical patron of carpenters and joiners.
A major part of the text deals with building houses, but
the edition dated to circa 1600 contains material devoted
to furniture-making. Together with its precious woodblock
print illustrations, this ancient treatise on joinery offers
extraordinary insights into the types, design, and con-
struction of Chinese furniture. However, there is no refer-
ence in it to the hardwoods of Ming furniture, although
many of the illustrations show familiar types associated
with them. This discrepancy may be due to the fact that
the text was probably compiled during the fifteenth cen-
tury, before fine hardwoods were used in large quantities
for furniture-making, while the illustration section was
probably added later, during the late sixteenth to early sev-
enteenth centuries.

3
Woods, Construction, and Design

The question of which woods were used in the making of Ming furniture is a rather complex one. Many twentieth-century writers have pored over the material and sources available, as well as conducting tests on a considerable body of the furniture itself. Their findings all point to the conclusion that the Chinese named woods according to their appearance, colour, and smell regardless of what types of trees they came from. As a result, sometimes more than one species of tree was called by the same name, providing that the timber they yielded fulfilled the requisite criteria. This also meant that even timber from the same tree but cut at different angles or from different parts might have been marketed under different names!

The art historian Craig Clunas, at the University of Sussex, has argued persuasively that under the circumstances the best solution is to retain the Chinese names for general use. This seems the most sensible as it will never be possible to match one Chinese name with one English and one botanical name.

Following then are brief descriptions of the main types of woods of which surviving examples of Ming furniture were made.

Huanghuali

A tropical hardwood of very fine texture, *huanghuali* shows a considerable colour variation ranging from pale honey to dark purple-brown. Often richly grained, it can be beautifully figured and was available in planks of considerable

size. It has a characteristic scent when worked and a natural golden sheen when polished which gives it a translucent quality. It varies in weight and is resistant to boring insects.

This is the material of which the majority of surviving fine Ming furniture is made, which probably reflects that during late Ming to early Qing, most fine hardwood furniture was made of *huanghuali*. It was seldom used after the mid-Qing. Tests have revealed that many pieces of Ming furniture were made of woods from species of the genera *Pterocarpus* and *Dalbergia*; these species have since been reclassified as *odorifera* of the genus *Dalbergia*.

Old texts referred to *huanghuali* variously as *hualü*, *lümu*, or *huali*; *huanghuali* is most likely a name given to the wood in Beijing, where the twentieth-century study of Ming furniture began. Hainan Island, off China's extreme south coast, was the major source for *huanghuali* within China; fourteenth- and fifteenth-century texts report that the wood came from the 'southern barbarian region' as well as Thailand and southern Vietnam. It was said that these woods grew in the mountains of the Li (one of the tribes on Hainan Island), and to obtain them one had to deal through the Li people. Outsiders, it was said, could not find or identify them, nor would the Li people allow them to.

Zitan

A tropical hardwood belonging to the genus *Pterocarpus* and the Leguminosae family, *zitan* made its appearance in Chinese texts as early as the third century AD. During the Ming and Qing dynasties, large quantities of it were imported. According to the botanist Chen Rong, the bulk of the cabinet wood traded under the name *zitan* was likely *Pterocarpus indicus*. It grows in India, the Philippines, the Malay peninsula, and China's Guangdong province.

Very few examples of Ming furniture made of *zitan* exist, but many examples from the mid-Qing onwards have survived. This may indicate that not many *zitan* pieces were made in the late Ming and early Qing, despite the wood's consistently high value.

Of all the hardwoods, *zitan* is the heaviest, the most closely grained, and the hardest. Its colour varies from a reddish-brown to the more familiar purplish-black. Some examples however are as black as lacquer, and the grain and figuring are hardly discernible. For the most part the grains are straight, although they occasionally have small wavy curls. When worked, the wood becomes a bright orange-red.

Jichimu

An unusual hardwood, *jichimu* has alternating purplish-brown and yellow lines which give the appearance of fine feathers when flat-sawn to expose the tangential grains. It is suspected that different species of the genus *Ormosia*, the red bean tree, have been termed *jichimu*. In texts it is sometimes written as *qizimu*, *jishemu*, and *xiangsimu*. It was variously reported as being grown in Hainan, Hubei, and Sichuan.

Tieli

From the tallest of all hardwood trees, *tieli* is also the least expensive wood used for making fine Ming furniture. The colour and the pattern of its grain somewhat resemble those of *jichimu*, but *tieli* is coarser in texture and more open in grain. It grows in the East Indies and also in Guangdong and Guangxi provinces where it has often been used for building houses.

The above woods are those of which the bulk of surviving Ming furniture was made. Many other woods, such as *wumu* (ebony), *huangyang* (boxwood), *jumu* (zelkova), different types of *nanmu* (cedar?), and *baimu* (cypress?), were mentioned in texts but few pieces made from them have survived. *Hongmu*, the southeast Asian rosewood of which large quantities of Qing furniture were made, is not discussed here, as the wood was not mentioned in texts before the eighteenth century and was only used extensively in China from the second half of the Qing dynasty.

It should be noted here that the Chinese *yingmu*, literally 'hard wood', is not identical to the English word hardwood. *Hardwood* refers to trees whose leaves fall off annually, and although their wood is usually dense and hard, there are certain types with low density. *Yingmu* refers to the richly grained dense tropical hardwoods of which Ming furniture was made. In Chinese furniture terminology, the opposites of *yingmu* are *zamu*, meaning 'miscellaneous wood', or *chaimu*, firewood, as opposed to softwood. It is the Chinese meaning of hardwood that we intend here throughout.

Construction and Design

The construction of Ming furniture utilizes a sophisticated system of joinery in which one member is joined to the next in a precise fashion, taking into account stress, function, and beauty. It has been observed by many authors that no other culture has produced furniture as beautiful in its integration of design and structure, with every member joined in a manner calculated not only to support the necessary stress, but also to enhance the beauty of the whole design.

This complicated and ingenious system of joinery has its origins in the New Stone Ages of 6,000 to 7,000 years ago. On the sites of the Banpo and Hemu cultures, evidence was found of wooden structures using lashed joints and primitive mortise and tenon joints. Excavations undertaken in the past forty years have yielded a large body of wooden objects from the Warring States period, and studies of those pieces have showed that several dozen types of joints were already in use, and that the principle and utilization of a basic form of modern-day joinery had already been invented and mastered by Warring States carpenters over 2,000 years ago.

We have scant information regarding the evolution of the Chinese joinery system from its basic form to the complicated, precise, and ingenious construction methods of Ming furniture, but it is certainly a worthwhile subject deserving of investigation. Meanwhile, Figure 3.1 provides examples from this comprehensive system. These joints

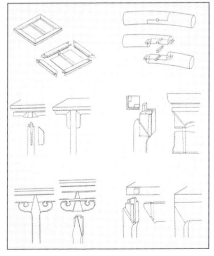

3.1 Examples of joints used in the construction of Ming furniture (source: courtesy Wang Shixiang).

allow for the accurate, stable, and all-directional linking of members of all sizes and shapes in a manner that enhances the beauty of the whole piece, and requires metal nails and glue only as auxiliaries.

The information available on the evolution of Ming furniture design is equally scarce. While we know that some designs were already in use hundreds of years prior to the Ming and that many were influenced by ancient architecture, how the Ming dynasty cabinet-makers arrived at their timeless, pure forms—with sometimes elegant, sometimes powerful but always perfect proportions—is also a subject worthy of investigation.

The names of the different designs of Ming furniture come from several sources, including the fifteenth-century carpenters' manual *Lu Ban jing jiangjia jing*, old texts and novels, twentieth-century Beijing cabinet-makers, and Western authors. Wang Shixiang has drawn from these sources to compile a comprehensive Chinese terminology for the different types. The names of the types discussed here will preserve his terminology in Chinese (spelled in *pinyin*), while in English, the terms have been chosen for their descriptive quality and clarity.

When there is an established English term, no translation from the Chinese is attempted; for example, the Chinese *sanwantui*, or 'three-bended-leg', is discarded in favour of 'cabriole leg'. Some terms which border on the ridiculous when translated are not used, and a simple descriptive term is adopted instead. Thus, 'S-shaped brace' replaces 'despot stretcher', *bawangcheng*. Some Chinese names have been retained on the strength of their long usage by cabinet-makers although they may not be precise. For example *yuanjiao gui*, 'round-cornered cabinet', refers to tapered wood-hinged cabinets normally made of round members

and consequently having round corners; however, those made of square members with square corners were also described with this term. The more appropriate name, 'sloping-stile wood-hinged cabinet', is therefore used instead.

Other names are either translated literally or phonetically or simply retained in Chinese when the approach offers a better solution than inadequate descriptive terms. The name of a specific design of chairs with low straight backs and arms, called *meiguiyi*, meaning 'rose chair', is retained rather than the more ambiguous 'low-back armchair'; and *kangji* or *kangzhuo*, the low tables used on the *kang* (the brick platform used as a warm living space in winter) are simply called *kang* tables rather than low tables. However, those Chinese names which when translated offer a less clear description of the types involved are discarded in favour of their more familiar Western descriptive names: 'horseshoe armchair' is used in place of 'circle chair', *quanyi*; and 'yoke-back armchair' is used rather than 'four protruding ends official's hat chair', *sichutou guanmaoyi*.

Following is a selection of the main types of Ming furniture that have survived, but no claims are made for the exhaustiveness of the list. All of the individual pieces illustrated here have only appeared on the art market within the past ten years and photographs of many are published for the first time here.

Chairs and Stools

Most Chinese chairs and stools of the Ming period seem to have had soft seats which were made by drilling holes in the frames and threading palm fibres through to form a web to support the matting. At times the matting was decorated with intricate designs, which were also threaded

through the same holes. Narrow wooden strips were then nailed to the frame with wooden or bamboo pins to hide the ends of the fibres. This formation provided a comfortable soft seat; moreover, by simply drilling out the pins, one could easily remove the strips to repair or replace the mat when necessary.

Ming chairs almost always have stiles which continue through the seat frame to become the back legs. This is often although not always true for the front posts and legs. This construction method makes enormous sense in terms of stability, although the timber used must meet more stringent requirements, especially for some designs where the rear stile-leg bends backward in an exaggerated curve. Ming chairs were always constructed with their own footrest in front, often in the form of a shaped stretcher.

Horseshoe armchairs, *quanyi*

The uniquely horseshoe-shaped arm and back seen in Plate 3 is made of five sections joined by pressure-pegged scarf joints. The decoration on the back splat, of playful hornless dragons, *chihulong*, is a motif often found on Ming furniture. So are the scrolling tendrils, *juancaowen*, found on the front aprons.

Yoke-back side chair, *dengguayi*

The vigorous top rail resembles a yoke, giving this chair its name (Plate 4). The legs splaying outward slightly and the C-curved back splat contrasting with the arch of the backward bending stiles all contribute to a sculptural tension often found on successful examples of Ming furniture. This type of chair was the most frequently depicted form in Ming dynasty pictorial sources.

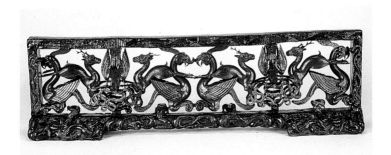

1. Lacquer screen excavated from Wangshan, Hubei province. Chu Kingdom, Warring States period (476–221 BC). Reprinted by courtesy of the Art Gallery, the Chinese University of Hong Kong.

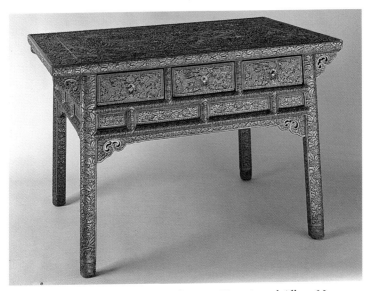

2. Carved red lacquer table. Xuande reign. Victoria and Albert Museum, London (FE.6–1973). Reprinted by courtesy of the Trustees of the Victoria and Albert Museum.

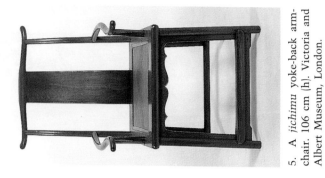

5. A *jichimu* yoke-back armchair. 106 cm (h). Victoria and Albert Museum, London.

4. A *huanghuali* yoke-back side chair, one of a pair. 49.5 cm (w) × 39.5 cm (d) × 109 cm (h). Museum of Classic Chinese Furniture, Renaissance, CA.

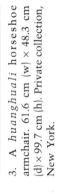

3. A *huanghuali* horseshoe armchair. 61.6 cm (w) × 48.3 cm (d) × 99.7 cm (h). Private collection, New York.

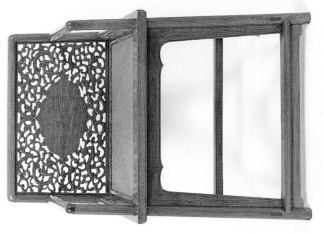

6. A *huanghuali* continuous yoke-back armchair; one of a pair. 59.7 cm (w) × 46 cm (d) × 120 cm (h). Private collection, Kerstein, Austria.

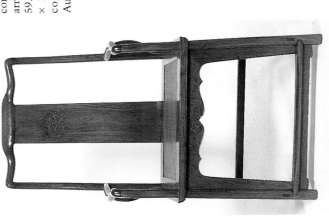

7. A *huanghuali* rose chair. 61.4 cm (w) × 46.8 cm (d) × 87.5 cm (h). Private collection, Brussels.

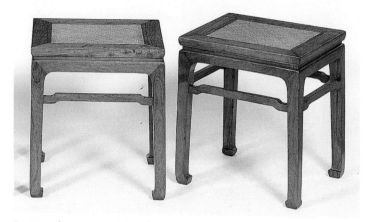

8. Two from a set of four *huanghuali* stools. 45.6 cm (w) × 40.1 cm (d) × 51.5 cm (h). Private collection, Hong Kong.

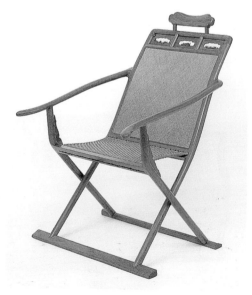

9. A *huanghuali* folding reclining chair. 72.1 cm (w) × 91.5 cm (d) × 101.3 cm (h). Museum of Classic Chinese Furniture, Renaissance, CA.

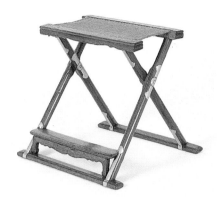

10. A *huanghuali* folding stool. 48.7 cm (w)
× 51 cm (d) × 46.5 cm (h). Private collection,
Hong Kong.

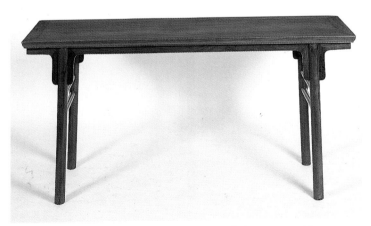

11. A *huanghuali pingtouan* table. 171.5 cm (w) × 49.5 cm (d) ×
83.2 cm (h). Private collection, Hong Kong.

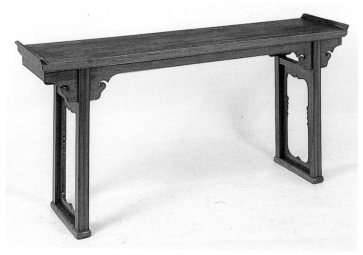

12. A *huanghuali qiaotouan* table. 179 cm (w) × 41.6 cm (d) × 83.4 cm (h). Private collection, Hong Kong.

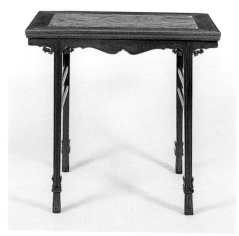

13. A small *huanghuali pingtouan* table with green stone top. 95 cm (w) × 58.5 cm (d) × 85.4 cm (h). Private collection, Johannesburg.

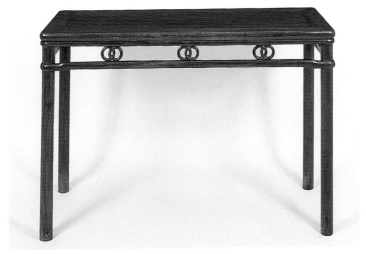

14. A *huanghuali zhuo* table. 124.5 cm (w) × 54.3 cm (d) × 83.5 cm (h). Private collection, Hong Kong.

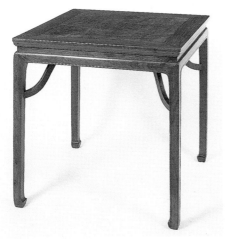

15. A *huanghuali* square table with burlwood top. 84.5 cm (w) × 84.3 cm (d) × 82.3 cm (h). Private collection, Minneapolis.

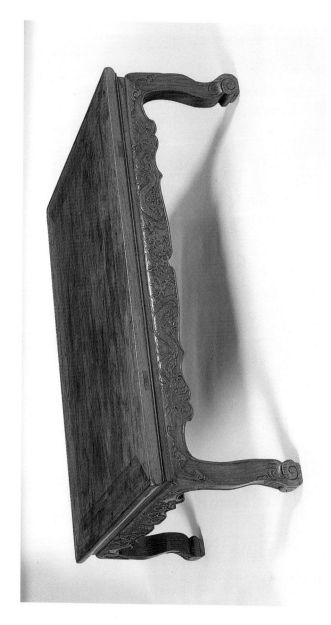

16. A *huanghuali* imperial *kang* table. 98.1 cm (w) × 70.6 cm (d) × 32.4 cm (h). Private collection, London.

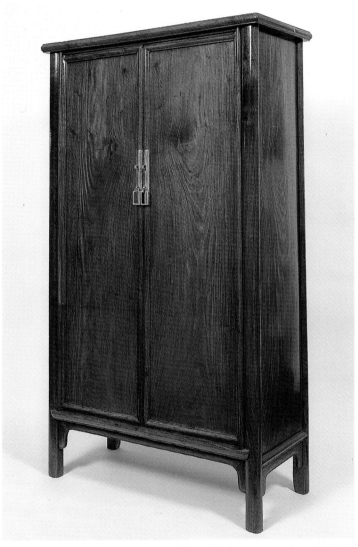

17. A *huanghuali* sloping-stile wood-hinged cabinet, one of a pair. 94.2 cm (w) × 41.9 cm (d) × 159.5 cm (h). Private collection, Hong Kong.

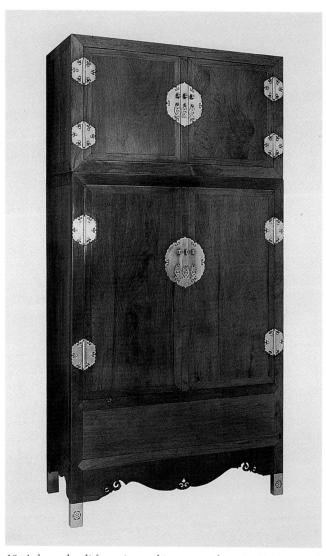

18. A *huanghuali* four-piece cabinet, one of a pair. 133.1 cm (w) × 62.5 cm (d) × 259.5 cm (h). Museum of Classic Chinese Furniture, Renaissance, CA.

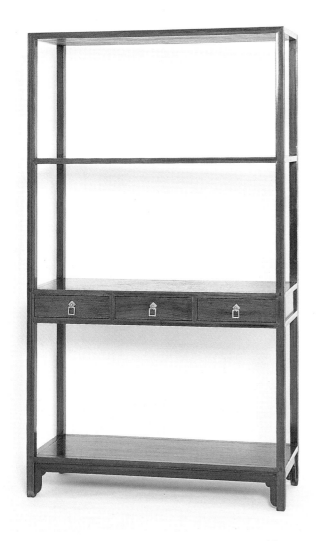

19. A *huanghuali* bookshelf. 111.2 cm (w) × 41.7 cm (d) ×
190.7 cm (h). Private collection, Seattle.

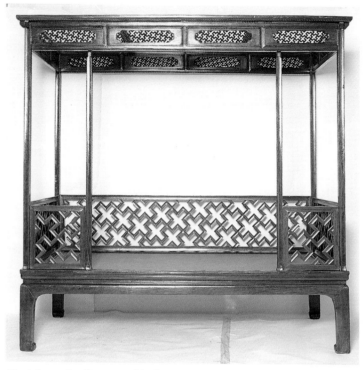

20. A *huanghuali* canopied bed. 214.5 cm (w) × 128 cm (d) × 211 cm (h). The author's collection, Hong Kong.

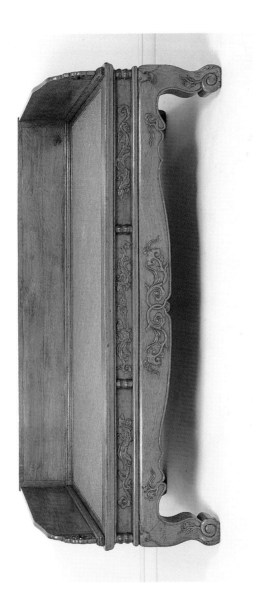

21. A *huanghuali* couch-bed. 201.5 cm (w) × 95 cm (d) × 78.5 cm (h). Private collection, Taipei.

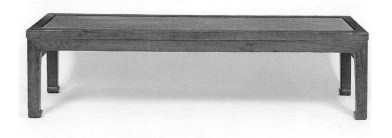

22. A *huanghuali* daybed. 213 cm (w) × 62.5 cm (d) × 53.1 cm (h). Private collection, Brussels.

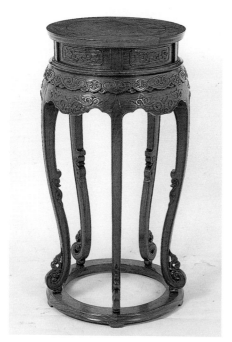

23. A *huanghuali* round incense stand. 44.5 cm in diameter × 81.6 cm (h). Private collection, Hong Kong.

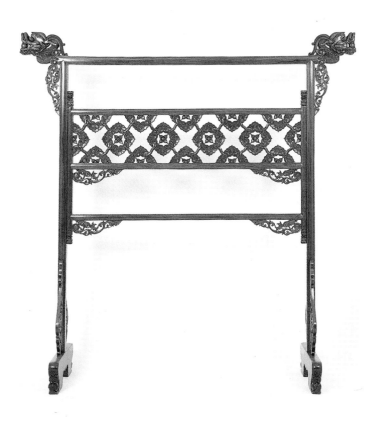

24. A *hunaghuali* clothes-rack. 186 cm (w) × 52.2 cm (d) × 185 cm (h).
Private collection, Hong Kong.

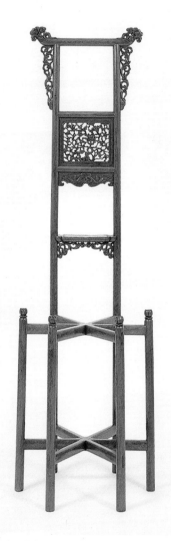

25. A *huanghuali* basin stand. 52.5 cm in diameter ×
177.5 cm (h). Museum of Classic Chinese Furniture,
Renaissance, CA.

Yoke-back armchair, *sichutou guanmaoyi*

This may be the earliest type of chair to emerge in China. Versions of it were depicted in the wall murals of the Dunhuang caves of the Western and Eastern Jin (AD 265–420), and Southern and Northern Dynasties, the period when Chinese people first began to use chairs. The beading on the seat frame and aprons of this otherwise completely plain chair (Plate 5) provide a subtle form of decoration often found on Ming furniture.

Continuous yoke-back armchair, *nanguanmaoyi*

This design, where the yoke-shaped top rail and arms no longer protrude but are joined to the stiles and posts, may be a refinement developed during the Ming (Plate 6). The extreme high backs, the finely executed carving, and the exaggerated curves of its members, all combining harmoniously, are some of the most distinctive characteristics of Ming furniture design.

Rose chair, *meiguiyi*

Prototypes of this design were frequently spotted in Song dynasty paintings. The standard design usually had aprons framing the back of the chair rather than the glamorous openwork carved panel seen on this example (Plate 7). The central medallion on this example was created specially for the calligraphy which describes windy, snowy fields.

Stools, *deng*

Ming stools were made in rectangular, square, round, and lobed shapes. Pictorial sources indicate they were the most frequently used seats, although that is not reflected in the

number of surviving examples. The set of four, two of which are shown in Plate 8, was constructed with a waist, *shuyao*, and hoofshaped feet, *mati*. The humpback-shaped stretcher, *luoguocheng*, is a common design feature.

Folding furniture

Folding furniture is of ancient origin. The Chu Kingdom folding bed (shown in Figure 1.2), excavated in 1987 from Baoshan, Hubei province, is over 2,000 years old. A Ming dynasty example of a folding bed can be found in the Palace Museum, Beijing. Both pictorial and textual sources indicate that folding chairs and stools seem to have been used widely in Ming households, although surviving examples are few.

Folding tables, both small and large, have emerged during the past few years to add to a body of folding pieces that gives credence to the theory that during the Ming, a special group of furniture was manufactured with folding mechanisms for a particular usage, for travelling or for easy storage. The folding table is also recorded in the fifteenth-century carpenters' manual *Lu Ban jing jiangjia jing*.

Folding reclining chair, zhedieshi tangyi

This very rare example (Plate 9) has marble *dalishi* inset panels, a lotus-shaped headrest, a chair back made of matting constructed like a soft seat, arms that lift up, and legs that fold up, all special features not often seen on Ming chairs.

The Ming pictorial encyclopedia, *Sancai Tuhui*, referred to this type of chair as the 'drunken old man's chair', *zuiwengyi*.

Folding stool, *jiaowu*

This form of seat was recorded as being used in China under the name of *huchuang*, or barbarian bed, as early as the Han dynasty almost two thousand years ago.

In the example shown in Plate 10, the seat has been strung with ropes, and reinforcements made of a white metal alloy called *baitong* are found at every joint, a common feature on folding stools and folding chairs with horseshoe-shaped arms and back. There is a footrest in front.

Tables

The Chinese words *an* and *zhuo* have been used for tables, sometimes together, sometimes interchangeably in old texts. Wang Shixiang in his definitive books on Chinese furniture has adopted the terminology of twentieth-century Beijing cabinet-makers to describe the two main types of Chinese tables, using *an* to refer to tables with legs that are recessed from the corners (Plates 11, 12, and 13) and *zhuo* to refer to those with legs at the four corners (Plate 14). The *an* type consists of those that are *pingtou*, flat-ended (Plates 11, 13), and *qiaotou*, those with everted ends (Plate 12). These distinctive names are clear in meaning, as are the types named for their shapes, like square tables, or those types unique to Ming furniture, like *kang* tables. However, naming tables after their functions—wine tables, painting tables, or lute tables—can sometimes be confusing, as the tables could be of any design and were also often seen in Ming pictorial sources being used for purposes other than what their names denoted. Some authors have chosen to name them according to strict construction terminology. This approach is suitable for a technical

manual but proves cumbersome for general readers. Therefore a combination is adopted here for the sake of clarity and simplicity.

One common construction feature unites the design of most Chinese tables: the usage of a mitred frame with a floating panel (see Figure 3.1). The frame members with mitred corners are cut, two with tenons, two with mortises, so they fit together to form a rectangular or square framework. The inside edges are grooved to house a central panel which is further supported by a stretcher that is tenoned into the framework and often dovetailed into the panel. This approach maximizes the usage of wood so that thin panels can be used over large areas and also allows for the expansion and contraction of the panel depending on the weather. This ingenious system of mitre, mortise, and tenon frame with floating panel construction was widely applied in Ming furniture design.

Pingtouan table

This classic design with legs recessed from the corners is perhaps the oldest form of table to appear in China. From the Warring States period over 2,000 years ago right up to the Yuan dynasty (1271–1368), excavated examples of this form with lacquered top and low bronze feet, mural paintings of its prototypes, scrolls and paintings depicting its various forms, and tomb models in *zamu*, miscellaneous wood, had already come to light before this Ming example. The simple, completely plain piece shown in Plate 11, with its slightly splayed round legs, typifies the purity of design common to many examples of Ming furniture.

The English term 'altar table', referring to both *pingtou* (flat-ended) and *qiaotou* (everted-end) Chinese tables with recessed legs, is a misnomer. These tables were used for

all sorts of purposes, and the heavy pieces used as altars in temples usually bore no resemblance to the Ming furniture made with fine woods.

Qiaotouan table

Qiaotouan denotes a recessed-legged table with everted ends. This design (Plate 12) is a *pingtouan* with rectangular legs, cloud-shaped spandrels, everted ends, flat floor stretchers, and decorative aprons between the legs.

Small *pingtouan* table

The small recessed-legged table shown in Plate 13 is a type of *pingtouan* but its legs are joined to the top using a different joinery system from the previous two examples, resulting in their being flush with their adjoining aprons and straight rather than slightly splayed. The central panel on the top is a figured green stone, a type apparently favoured in Ming furniture manufacture.

This size of *pingtouan* is often referred to as a wine table by Beijing cabinet-makers.

Zhuo table

The term *Zhuo* denotes a table with legs at the four corners. The design of this piece (Plate 14), with its round legs and rounded members, took its influence from bamboo and cane furniture—down to the double ring struts which were a decorative motif often found on the bamboo and cane furniture depicted in Song and Ming paintings.

Square table

By construction, this table (Plate 15) is a *zhuo*. It also has a waist and hoof feet. The distinctive S-shaped supporting

braces are called *bawangcheng* and are unique to Chinese furniture of this period.

Burlwood, with its tight grape seed pattern, was sometimes used instead of stone or other woods for table tops. Square tables were called eight, six, or four immortals tables according to how many people they could seat. They were primarily but not exclusively used for dining.

Kang table

In many Chinese houses, a hollow brick platform called a *kang*, which is heated by hot air from the cooking stoves, is used to create a warm living space. A waisted low table with cabriole legs is often situated on the *kang* and may be used for eating or domestic chores.

The aprons of the table shown in Plate 16 were carved with long-bodied, realistically depicted five-clawed dragons, the imperial emblem. To date this is the only full-scale hardwood furniture piece found with dragons so rendered.

Cabinets and Shelves

It would appear that Ming dynasty cabinets were made in pairs while bookshelves may have been made in pairs or singly. Most of the doors and inside shelvings of cabinets also seem to have been made to be removable. The inside shelves, drawers, and the backs of cabinets were usually made of secondary woods like elm or pine, and protective coatings of ramie sealed with clay and lacquer were often though not always applied to these surfaces. The metalware served as functional hinges, pulls, and plates as well as decorations, and was often made of *baitong*, an alloy of copper, nickel, tin, and zinc, although *huangtong*, yellow brass, was also used.

Sloping-stile, wood-hinged cabinet, *yuanjiao gui*

One of the most ingenious and beautiful designs in Ming furniture is the sloping-stile, wood-hinged cabinet. The four main stiles are recessed from the top corners and slope gently outward in a subtle, almost imperceptible splay. This simple design feature gives the cabinet its refined elegance and a sense of balance and stability (Plate 17).

The doors, with extended dowels on both ends, fit into sockets in the cabinet, thereby making hinges unnecessary and preserving the cabinet's clean lines. The doors, inside shelves, and drawers are all removable. This type of cabinet often has a removable central stile between the doors.

Four-piece cabinet, *sijian gui*

These cabinets (Plate 18) are called four-piece cabinets because the top and bottom sections are separate, and as they were made in pairs, a complete unit was comprised of four pieces. By construction, they fall within the group called *fangjiao gui*, square-cornered cabinets which look similar to the bottom section of the present example. Four-piece cabinets were usually made in large sizes, and all the doors, central stiles, inside shelves and drawers were removable. Their design was often completely plain, with metal plates and sometimes shaped aprons being the only decoration.

Bookshelf, *jiage*

Surviving examples of Ming bookshelves are very rare, so no groupings into different styles and types are possible. The few known examples are extremely simple in design and totally functional but possess such perfect proportions as to transcend time.

The piece shown in Plate 19, with three shelves and three drawers, is made of *huanghuali* throughout, a very refined feature.

Beds and daybeds

Ming beds, like chairs and stools, were predominantly made with soft seats and were used both for sitting and sleeping. Curtain-like hangings were used on canopied beds, while screens and pavilion-like structures were sometimes put around couch-beds or daybeds to create an enclosed space simulating a small room.

Canopied beds have four or six posts, and the elaborate models on platforms even have balustrades, delimiting a corridor in front of the bed where small tables and stools might be placed and creating a living space like a bed chamber.

Couch-beds and daybeds came in various sizes. The arms and backs of couch-beds were made either with solid planks or openwork panels, while daybeds did not have attachments and resembled large benches.

Canopied bed, *jiazichuang*

In all of the examples found, the posts, railings, top decorative panels, and the canopy were designed to be detachable from the seat, perhaps for portability but more likely for easy access to repair or replace the soft mat seat (Plate 20). The openwork railings in this example, with the character for ten thousand, *wan*, were comprised of small thumb-moulded members mortised and tenoned together to form the pattern inside the frames, while the top panels were carved with very much smaller versions of the same pattern.

Couch-bed, *luohanchuang*

The exquisite example shown in Plate 21 is made from honey-coloured *huanghuali* and decorated with superb carvings of *chihulong* (hornless dragons) and *juancaowen* (tendrils). The arms and back are removable.

The origin of the Chinese name *luohanchuang*, 'monk's bed', is obscure. Modern cabinet-makers use this terminology in both northern and southern China.

Daybed, *ta*

The term 'daybed', denoting bench-type beds with no arms, back, or railing, is slightly misleading in that these beds were also used as regular beds in Ming dynasty China. The word *ta*, normally referring to smaller beds of all sorts, has been appropriated by furniture experts to refer to beds of this design.

The present example (Plate 22) is completely plain with all the surfaces flat and the top slightly overhanging the apron. There is no waist, but there are hoof-shaped feet, although the two features are normally associated with each other. This combination of features is a distinctive design trait of Ming furniture and is found also on tables and stools.

Stands

Stands comprise a group of Ming furniture which has more or less lost its *raison d'être* over the last few hundred years; perhaps as a result few examples have survived. In fact, not one piece of the recorded types of drum stands, flowerpot stands, and musical instrument stands has yet come to light.

Incense stand, *xiangji*

Recorded as a standard type in the fifteenth-century carpenters' manual *Lu Ban jing jiangjia jing*, incense stands were also often portrayed in illustrations to late Ming novels, although there are few extant examples. Incense stands were made in round, square, lobed, or rectangular shapes.

This five-legged, round, high-waisted piece (Plate 23) has layered aprons carved with scrolling cloud designs and decorated cabriole legs that are tenoned into a round foot stretcher.

Clothes-rack stand, *yijia*

The clothes-rack stand is an even rarer type, with the present piece (Plate 24) being one of very few whose whereabouts is known. The extremely fine carving combines various decorative motifs of dragons, *lingzhi* fungus, and lotuses reminiscent of Ming-era houses in Shexian, Anhui province.

Basin stand, *mianpenjia*

The tall basin stand shown in Plate 25 has exquisite carved decorations of *lingzhi* and floral motifs. This is also a standard type recorded in the *Lu Ban jing*. Surviving examples of basin stands are rare.

4

Interior Decoration

Our impression of the interiors of houses of the Ming dynasty has derived from a combination of contemporary paintings, especially those of the genre that depicts scholars reclining on daybeds while contemplating, playing the lute, or enjoying an old scroll and surrounded by precious antiques and elegant furniture. We also rely on the writings of these scholars on elegant living, which sometimes include descriptions of interiors. Even more striking are the many wood-block print illustrations found in all types of literary works. The popular novels and operas widely published during the late Ming were particularly rich in illustrations of interior situations. It is to this large body of illustrations that we now turn for an understanding of furniture arrangement in sixteenth- and seventeenth-century China.

The aim of these woodblock prints was to bring to life the stories being told, so there is no reason to suspect that the scenes portrayed reflect anything but the lifestyle of the time. The author has examined over 6,000 woodblock print illustrations from publications of the late Ming and early Qing. No claim is being made as to the exhaustiveness of the reference material. All the woodblock prints used here are dated to the late Ming, mostly from the third quarter of the sixteenth century to the early years of the Qing dynasty, before the reign of the Kangxi Emperor. All of them were published in the Jiangnan area.

An illustration to the Ming dynasty drama *The Story of Hong Fu*, portrays the popular leisure activity of eating and

drinking (Fig. 4.1). Three people seated on stools around a square table enjoy a cup of tea or wine and a plate of food. The drum-shaped stools appear to be made of rattan or cane, and seat covers made of brocade or fabric are draped over them. A floor screen decorated with a painting of rocks and trees dominates the room. The central figure has his sword girthed to his waist, and his luggage and umbrella are under the dining table. This scene of an apparently hasty meeting takes place right next to the cellar, with its many jars of wine visible behind the screen.

Another illustration of eating and drinking is found in *A Pair of Fishes*, published during the Wanli period (1572–1620). In the chapter entitled 'Refusal of a Proposition', two gentlemen are shown enjoying a meal in a house of

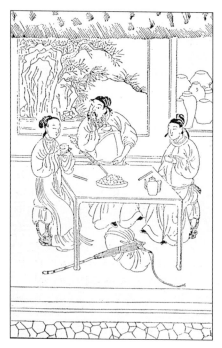

4.1 People eating in an informal setting, from the Wanli drama *The Story of Hong Fu* (source: Fu 1978, vol. 1).

pleasure (Fig. 4.2). Wine and food have been placed on a *pingtouan* table, a classic of Ming design, while the diners sit across from each other on low stools with bulging legs. The meal is being eaten near the garden or courtyard where the young lady who was propositioned is being encouraged by an old woman. Musical instruments hang on the wall of the room.

A more formal setting for meals is depicted in another

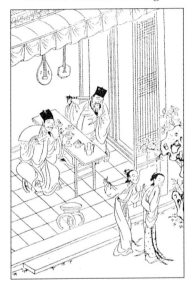

4.2 A meal in a house of pleasure, from the Wanli drama *A Pair of Fishes* (source: Fu 1978, vol. 1).

Wanli publication, *A Thousand Ounces of Gold* (Fig. 4.3). The host and guests all have their own dining tables and are seated on chairs rather than stools. In addition, the tables are tied with frontals and hangings on the sides. The chairs are adorned with covers. A large floor screen with a painting of mountains has been placed in the centre, and behind it is a side table on which is displayed a selection of what appear to be bronze vessels.

Table frontals and chair covers are also used in a larger

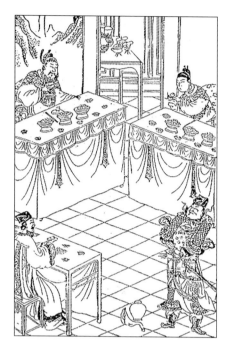

4.3 A small formal banquet, from the Wanli drama *A Thousand Ounces of Gold* (source: Fu 1978, vol. 1).

dinner party scene (Fig. 4.4). This is an illustration from the popular late Ming historical novel *The Outlaws of the Marsh*, showing the ranks of the rebel heroes at their headquarters, Liang Shan Po. Six rectangular tables are laid out with food and drink, and four to six people sit around each on chairs rather than stools. All the chairs are of a design we now call yoke-back chairs. Pots of flowers are placed in groups around the terrace.

From the same source is an illustration of an official banquet (Fig. 4.5). An even more formal arrangement is portrayed, with the representative of the emperor seated on a throne at his own table while his guests, the rebel army he is trying to persuade to return to court, are seated side by side at very long tables. All the furniture has been dec-

orated with coverings. A rug is placed in the centre of the room for the dancers who entertain the assembly. Musicians play in the courtyard.

These five prints indicate the variety of places where meals might be served, as well as the different types of tables and chairs used for dining. Meals were served in halls, near cellars, on terraces, and in rooms hung with musical instruments. Dining tables were square or rectangular *pingtouan* or *zhuo* style, and banquet tables were sometimes very long. Even more striking is how the furniture seems to have been tailored and arranged depending on need and occasion. It was apparently an established custom that tables and chairs were adorned with brocades

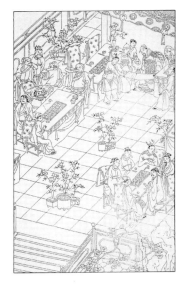

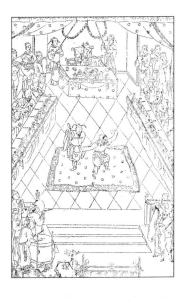

4.4 A large formal banquet, from the Wanli historical novel *The Outlaws of the Marsh* (source: Zheng 1958, vol. 2).

4.5 An official banquet, from the Wanli historical novel *The Outlaws of the Marsh* (source: Zheng 1988, vol. 2).

or fabrics for more formal occasions like banquets.

It is also clear that different types of seats were ranked in a hierachy. Chairs were used for more formal occasions while stools were often used in less formal settings.

Giving emphasis to these points, Figure 4.6 shows a bedroom with a canopy bed in the centre, its occupant resting behind the bed curtains while a lady hovers over him. On a nearby square table, a meal for two has been laid out and stools are placed casually before it.

Bedrooms in the Ming dynasty, unlike dining rooms, seem to have been much more defined spaces, if only because of the difficulty in moving full-sized canopy beds from room to room!

4.6 A snack laid out in a bedroom, from the Wanli historical novel *The Outlaws of the Marsh* (source: Zheng 1988, vol. 2).

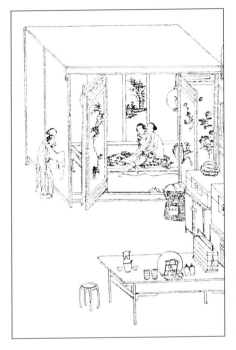

4.7 A scene in a bedchamber, from the Chongzhen novel *The Golden Lotus* (source: *Jin Ping Mei Cihua*, chap. 97).

A typical arrangement is illustrated in Figure 4.7, which depicts a scene from *The Golden Lotus*. The bedchamber surrounding the bed is comprised of panels of either paintings or embroidery topped with a canopy to create a room within a room. The daybed is wider than most of the extant examples in this category. The platform of the bed is made of either matting or rattan. A clothes rack is placed nearby.

Chests of a design still copied today in camphor wood are placed on top of low cabinets. A large table, which would almost certainly have drawers on the front, is placed on the other side of the room, quite a distance from the bed. A simple round wooden stool is placed next to it. The

table seems to serve in part as a dressing table, since a mirror is placed on a stand at its centre. A three-tier carry-box, often used for food, stands on one side, and cups and a teapot are kept on the other side.

Figure 4.8 is an illustration from the Yuan dynasty opera *The Thorn Hairpin*, published during the Wanli period. It shows a room with a mottled bamboo canopy bed and a long footrest in front. A table has been pulled against the bed and scissors and what might be other implements for sewing have been placed on it. A drum-shaped stool tied with an embroidered or patterned cover stands next to the table.

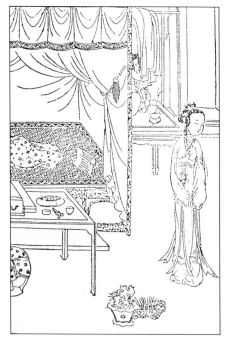

4.8 A scene in a bedroom, from a Wanli edition of the Yuan dynasty opera *The Thorn Hairpin* (source: Fu 1978, vol. 1).

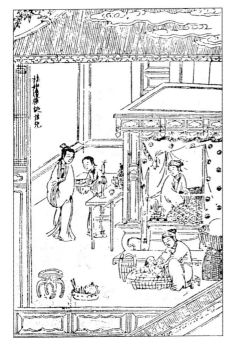

4.9 Activities in a bedroom, from the Tianqi novel *Forgotten Tales from the Zen Adherents* (source: Fu 1978, vol. 2).

The bed chamber as a room within a room is again created here, not by panelled surrounds but by lavish bed hangings and curtains. Curtain hooks are used to hold the draperies back in the daytime so the bed can be used as a sofa or seat, in this case for sewing or embroidery. A clothes rack stands behind the bed near another table, on which are placed two vases of flowers and a censer, with incense burning.

Other activities besides sewing also take place in the bedroom. In a scene from the Ming novel *Forgotten Tales from the Zen Adherents* (Fig. 4.9), published during the reign of the Tianqi Emperor (r. 1620–27), a mother sits inside an elaborate canopy bed festooned with curtains and hangings

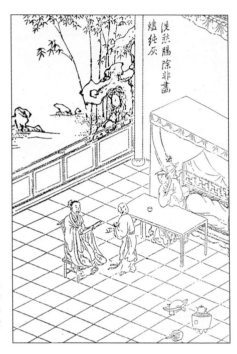

4.10 Receiving a guest in the bedroom, from the Chongzhen drama *Figure Inside the Painting* (source: Fu 1978, vol. 2).

while the midwife or nurse bathes her newborn baby. A long footrest is placed in front of the bed, while a table of classic Ming design is used as a night table. A brazier is placed on the floor and next to it stands a wooden stool with bulging legs. Note that the stool the midwife is sitting on is very low, even compared to the small wooden stool, perhaps an indication of the sitter's status. A tall basket, presumably for clothes, stands directly on the floor right next to the bed. (A similar basket was also placed next to the bed in Figure 4.7.) No extant example of this type of basket has survived, so its exact function is not entirely clear. The bedroom seems to be a hub of activity, with a visitor arriving and a servant girl bringing tea on a tray.

The gentleman in Figure 4.10 is also receiving a guest in his bedroom, who is much honoured it would seem, as he is seated on a chair rather than a stool. A large table is again pulled against the bed and appears to be arranged so as to be leaned against when the bed is used as a seat. Bed curtains adorn the four-post canopy bed. This print is an illustration from the drama *Figure Inside the Painting*, published during the Chongzhen period (1627–44).

The variety of purposes one's bedroom might serve can be seen in a Ming woodblock illustration to *Jingqi Xiang* (Fig. 4.11). In the background is a magnificent six-post canopy bed with railings of a *wan* pattern (the character for ten thousand) hung with lavish curtains, the front ones

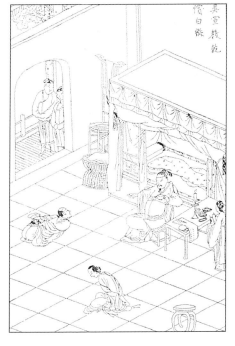

4.11 Justice being dispensed in a bedroom, from the Ming dynasty novel *Jingqi Xiang* (source: Zheng 1940, vol. 15).

pulled back by curtain hooks. Next to the bed are a clothes basket and a tall wash-basin stand with a basin in place and a towel thrown over the top.

The master is seated on a chair with drink in hand, and the rectangular table next to him is laid with brush, ink-stone, paper, and what appear to be plates of food. Meanwhile, he is measuring out justice to some offending souls tied up on the floor.

Other rooms also seem to have been used for sleeping. For gentlemen of the Ming dynasty, a bed was often installed in the study or *shufang* (book-room). In an illustration to the early Qing opera *Wan Jin Qing Yin*, published in 1661 (Fig. 4.12), a scholar–gentleman is shown resting on a couch-type bed, against the backdrop of a large bookcase filled

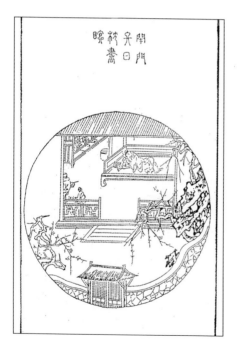

4.12 A scholar resting in his study, from the early Qing dynasty opera *Wan Jin Qing Yin* (source: Fu 1978, vol. 2).

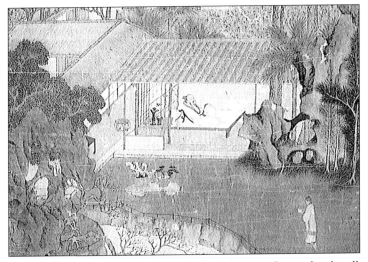

4.13 A gentleman reclining in his study, from the Ming dynasty handscroll *The Forest Pavilion's Enchantment* by Qiu Ying (source: Qiu 1987).

with books and scrolls. Contemporary paintings also provide ample illustrations of gentlemen reclining on daybeds in their studies, as in the handscroll *The Forest Pavilion's Enchantment* by Qiu Ying (1494–1552) (Fig. 4.13). These beds were often couches with low backs and arms or simply large benches with matting or rattan seats.

The concept of a living room or reception room where furniture pieces are permanently arranged in a certain manner to receive guests or to conduct one's daily family affairs may not have been a widespread one in China until the Qing dynasty. On examination of woodblock prints made in the late sixteenth to early seventeenth century, one is struck by the fluidity of arrangement of furniture in situations that would come under the scope of activities conducted in living rooms today. In the texts of the novels where these woodblock illustrations originated, there were

also frequent references to rooms where only one chair was placed for the chief protagonist to sit while the rest of the company would stand!

An illustration from the Wanli drama *The Story of the Red Pear* might illustrate a typical scene of a host receiving a guest (Fig. 4.14). A massive floor screen with a landscape painting dominates the space shown. Two yoke-back armchairs are placed in front of the screen where the host and guest sit facing each other. An attendant emerges from behind the screen, bringing refreshments on a tray. No other piece of furniture is visible, no spare chair or stool, no 'tea table', the customary piece placed between chairs in the Qing dynasty.

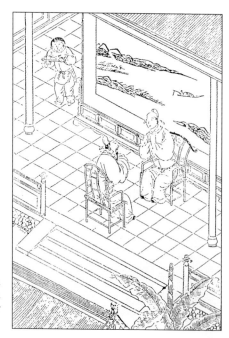

4.14 A host receiving a guest, from the Wanli drama *The Story of the Red Pear* (source: Fu 1978, vol. 1).

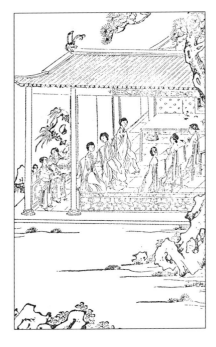

4.15 A host or hosts receiving many guests, from the Chongzhen short story collection *Bells on a Clear Night* (source: Fu 1978, vol. 2).

A larger party of guests is being received by the host or hosts in an illustration from the short-story collection *Bells on a Clear Night*, published during the Chongzhen period (Fig. 4.15). Rows of three chairs have been placed facing each other. Chair covers are used, denoting a more formal occasion, confirmed by the presence of attendants standing on the sides bearing gifts. A large table is at the head of the room, but no other piece of furniture is visible.

From *The Golden Lotus* comes another illustration that conforms more readily to the modern concept of a living room (Fig. 4.16). The matchmaker, an old woman called Xue, has brought Ximen Qing, the central figure in the novel, to the house of the wealthy widow Meng Yu Lou. They are seen here in her *menlou*, 'room at the entrance'.

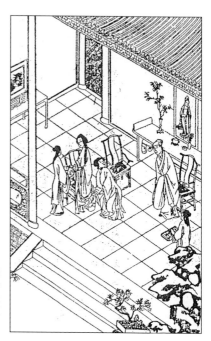

4.16 A matchmaker introducing the prospective couple, from the Chongzhen novel *The Golden Lotus* (source: *Jin Ping Mei Cihua*, chap. 7).

There is a hanging scroll of Guanyin in the centre, and placed against it is a long *qiaotouan* table with panel feet carved in openwork of *lingzhi* fungus, a design that is seen in excellent surviving examples dated to the Ming. Vases of flowers adorn the table. Against the side wall is a *zhuo* table on which stands a large table screen with inset marble. Behind the screen is hung another painted scroll. This display would seem more or less permanent.

The three beautiful yoke-back armchairs in the centre of the room, two side by side and the third at an angle, appear to have been last-minute additions. Two servant girls bring tea and refreshments on trays.

This loose arrangement of chairs and tables is even more evident in an illustration from *The Outlaws of the Marsh*

(Fig. 4.17). The leader of the rebels, Song Jiang, sits in his official robes on a high yoke-back armchair with a footrest in front. He is flanked by two more yoke-back armchairs, and one of them is occupied by one of his lieutenants. All three chairs have brocade or silk covers. Two tables in the foreground, one placed at an angle, are being used as desks by two men sitting on covered yoke-back armchairs. One of them is seen, brush in hand, busy preparing a document to be delivered to the enemy. An inkstone and a brush pot with a selection of brushes have been placed on the desk. A tall circular stand with cabriole legs and floor stretchers is visible behind the pillar. Placed on it is an incense burner and containers for its implements. It is worthwhile to note that this 'informal' arrangement of furniture is deemed entirely appropriate by the artist for a rather official and significant occasion, the central figures dressed in their official robes, the many armchairs covered with brocade or silk.

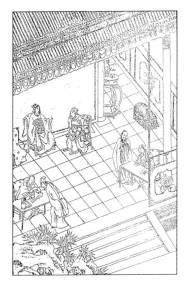

4.17 The leader of the rebels, from the Wanli historical novel *The Outlaws of the Marsh* (source: Zheng 1988, vol. 2).

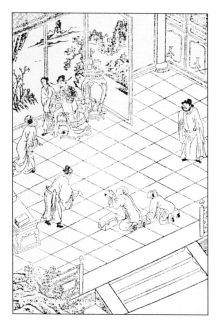

4.18 An official at work, from the Chongzhen novel *The Golden Lotus* (source: *Jin Ping Mei Cihua*, chap. 18).

Another example of what a Ming dynasty artist considered an appropriate setting for an official at work can be found in an illustration from *The Golden Lotus* (Fig. 4.18). This scene depicts the messengers dispatched by Ximen Qing bearing gifts to bribe an official in an attempt to pervert the course of justice. The space is dominated by a large folding screen with panels of landscape paintings. Near the edge of the screen is placed a large, tall incense stand, round and with cabriole legs and floor stretchers. Next to this stand, the official sits on what appears to be a horse-shoe-back armchair, draped with a lavish seat cover and a lotus-shaped footrest in front. A table with everted ends and base stretchers is placed near the centre of the room. The arrival of Ximen's messengers is being announced by attendants. No other piece of furniture is visible.

After these depictions of official gatherings, it comes as
no surprise that in the ladies' quarters, furniture arrange-
ment is also rather flexible. An illustration from the Qing
dynasty drama *Feng Qiu Huang*, published during the
Shunzhi period (1644–61), shows three ladies seated on
rose chairs, all casually placed against a backdrop of a *qiao-
touan* pushed against the wall where a scroll hangs (Fig.
4.19).

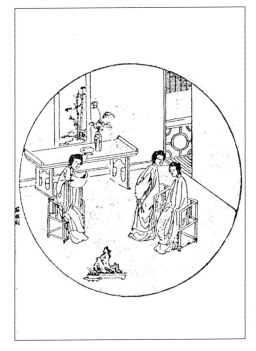

4.19 Ladies' quarters,
from the Qing dynasty
drama *Feng Qiu Huang*
(source: Fu 1978, vol. 2).

Perhaps it was only in the palaces and the court circle
that reception rooms with fixed furniture arrangements
were maintained during the Ming dynasty. An illustration
from *The Outlaws of the Marsh* depicts the rebel Chai Jin

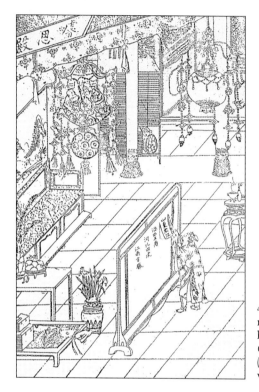

4.20 A court reception room, from the Wanli historical novel *The Outlaws of the Marsh* (source: Zheng 1988, vol. 2).

entering the forbidden palace (Fig. 4.20). A large folding screen sets the space for a throne or a small couch, complete with a long footrest. Next to the seat is a side table with a flower vase and a fruit plate on top. A low daybed, a *ta*, is placed next to the table, on which lie several books. There is a large floor screen in the centre and a round, cabriole-legged incense stand on the right. Behind the pillars is a bookcase piled with books and scrolls. An inscription above the hall reads Rui Si Palace.

Finally, given the flexibility of Ming furniture arrangement, it is hardly surprising to find in the encyclopedia *Sancai Tuhui*, in the section covering reception halls, an illustration of a pavilion containing only two chairs, placed diagonally facing each other (Fig. 4.21).

4.21 Illustration of a reception room, pictured in the *Sancai Tuhui* (source: Wang 1958, vol. 2).

5
Twentieth-century Developments in the Study and Collection of Ming Furniture

In February 1977 I purchased two books, *Chinese Domestic Furniture* (Vermont and Tokyo, 1962) by Gustav Ecke, and *Chinese Household Furniture* (New York, 1962) by George N. Kates. At the time these were the only two books generally available on Chinese furniture and being eager to study the subject, I extended my search to specialist book dealers. A third book, *Chinese Furniture* (New York, 1971) by Robert Ellsworth, had been published only a few years before, but I was advised that this book was very expensive and difficult to obtain. In addition, I was told about *Les Meubles de la Chine* (Paris, 1921) by Odilon Roche and its English translation *Chinese Furniture* (London, 1922) by Herbert Cescinsky, but these two publications included examples of lacquered furniture only and were out of print.

I was surprised that so few publications were available and astonished to discover that there was no book on the subject in Chinese. Only a handful of articles on furniture had been published in specialized journals in China. Later, I was to find out that this mirrored the different degrees of interest in the subject shown by different quarters at the time.

Ecke's and Kates's books revealed that twentieth-century study and collection of Ming furniture might have begun in the 1930s, in Beijing. Prior to that time, interest in Chinese furniture focused on lacquered pieces. Kates's book was first published in 1948, after he had left Beijing to work at the Brooklyn Museum in New York. The book,

however, was based on photographs his sister and two friends had taken in the winter of 1937–8, in their desire 'to make a record of the best furniture they saw in the houses of their friends, other "foreigners" . . . like themselves' living in Beijing.

Professor Gustav Ecke first went from Germany to teach in China in 1923 and remained there until 1948. He was devoted to the study of many aspects of Chinese art, and the result of his investigation on Ming furniture, *Chinese Domestic Furniture*, was first published in folio form in 1944 in Beijing, using material from his own collection and those of other foreign residents in Beijing.

Ecke attributed his interest in Ming furniture to the inspiration of Professor Deng Yizhe, 'who furnished his home in Peking with rosewood pieces in the Ming style, and did not surrender to the taste of the day'. There were records of Chinese collectors of reknown owning Ming furniture, notably Pu Tong, Guo Baochang, Guan Boheng, and especially Zhu Youpin, who formed a sizable collection. However, there is scant evidence that Ming furniture was widely appreciated by the Chinese populace. Neither did scholars make any attempt to research it.

Thus Ming furniture collection and study began in Beijing's foreign community. This trend was felt by visiting scholars and businessmen, and pieces entered both private and museum collections in America. In 1946, under the guidance of Laurence Sickman, former Beijing resident and now vice-director of the Nelson-Atkins Museum of Art in Kansas City, the Nelson-Atkins Museum bought its first large group of *huanghuali* furniture from Otto Burchard, the Berlin-based dealer who visited Beijing regularly on buying trips. John F. Kulgren of Washington, DC, formed a collection of hardwood furniture that went on exhibition at the Los Angeles County Museum in 1942. Thirty-four pieces of

furniture from the collection of William Drummond, who 'during his long stay and extensive travels in China collected them himself', formed an exhibition of Chinese furniture at the Baltimore Museum of Art in 1946, according to the museum bulletin. In 1947 the Art Institute of Chicago received a pair of *huanghuali* yoke-back armchairs given in memory of Dr H. F. MacNair, who taught from 1921 to 1927 at St. John's University in Shanghai. Russell Tyson, another Shanghai resident, and heir to the Shanghai firm of Russell and Co., also bought Chinese furniture, some of which was donated to the Art Institute of Chicago after his death in 1964. These early movements formed the foundation of America's holdings of Ming furniture. In Europe, the influence of Ecke and his circle was less strongly felt, and as a result the art trade and popular perception continued to be dominated by lacquered furniture.

The communist take-over in 1949 dispersed Beijing's foreign community in all directions. Some were able to take with them their prized possessions, including furniture. Together with the pieces that had been exported before the take-over, these were to become the nucleus of the many collections formed in the 1950s, 1960s, and 1970s, both public and private.

During the 1950s, Gustav Ecke went to Hawaii to work as the curator of oriental art at the Honolulu Academy of Arts and was responsible for the important surge in the collecting of Chinese art, furniture in particular, not only at the academy but all over Hawaii. His influence was even more widely felt when his seminal work on Chinese furniture was republished in 1962, making it more widely available.

The collection of George Kates, now the curator of oriental art at the Brooklyn Museum, was auctioned in 1955. Four lots of furniture were bought by Mrs Henry Norweb,

who subsequently donated them to the Cleveland Museum of Art.

More recently, influential and charismatic dealers have entered the field, notably Alice Boney, and later her protégé Robert Ellsworth, and Charlotte Horstmann, based in Hong Kong. From the 1950s to the 1970s they introduced great treasures to many private and museum collections, including the Philadelphia Museum of Art, the Museum of Fine Arts in Boston, the Metropolitan Museum of Art, and the Nelson-Atkins Museum, which has become the mecca for students of Ming furniture. Many illustrious names in the world of finance, business, and politics include Chinese furniture in their art collections.

In Europe, museums benefitted from the properties brought home by their nationals who fled Beijing. The Victoria and Albert Museum in London, in response to a change in Western taste, bought its first piece of Ming furniture, a *huanghuali pingtouan* table, in 1969. The bequest of a collection of Ming furniture by the British diplomat Sir John Addis, who had lived in Beijing, further enriched the museum's holdings.

By contrast, Ming furniture made not a ripple in the Chinese-speaking world of Hong Kong, Taiwan, and Singapore during the corresponding period. In communist China, the land reform movements of the 1950s were followed in the 1960s by the Cultural Revolution, disrupting the daily lives of its citizens. In such a turbulent climate, the study and collection of art received little attention. The antique shops which supplied the Beijing community with their Ming furniture, such as Rong Xing Xiang, Yunbao Zhai, Luban Guan, and Tienhe Zhai, all went out of business under the communist regime, and the tricklings from the primary source ceased altogether. The only available materials for study and collection were assumed to be in the West.

In the antique shops of Hong Kong, the furniture available was the heavily carved, sometimes inlaid with mother-of-pearl, blackwood 'palace' style of late Qing and twentieth-century manufacture. Chinese collectors of ceramics and paintings bought these *hongmu* and *zitan* wood pieces to decorate their homes. Charlotte Horstmann arrived from Beijing and ran a flourishing interior decorating business which also supplied Ming furniture reproductions. These were enthusiastically received by the expatriate community as well as by visitors, mainly Americans. Eastern-based connoisseurs of Chinese furniture, among them the prominent Chinese art collectors Dr K. S. Lo and Sir Joseph E. Hotung, were to look west for their material and inspiration. The dramatic events of the 1980s were to completely reverse this situation.

In March 1981, the United Nations Industrial Development Organization (UNIDO) conducted a seminar on Wood-based Panels and Furniture Industries in Beijing, and among the participants was the art historian Wang Shixiang. His topic was conventional Chinese furniture. Most of the pieces illustrated in his paper were familiar from private and museum collections in the West, but there were a few pieces not known to this author, an avid cataloguer of Ming furniture. The following year, Wang was invited to London to lecture to the Furniture History Society, an event held in conjunction with the Victoria and Albert Museum. Thus, an unsuspecting world was exposed to a post-1949 Beijing where Wang collected, dissected, and researched Chinese furniture. There were others like Wang and, with the opening up of China, Beijing's community of historians and collectors was able to make its impact on the world of furniture lovers.

In the early 1980s, over a dozen research papers by Chinese scholars were published in China in the specialized but

widely circulated magazines of *Wenwu* and the Palace Museum journals. Excavation reports further added to the body of knowledge on furniture.

In 1985, *Mingshi Jiaju Zhenshang* (The appreciation of Ming furniture) by Wang Shixiang was published to wide acclaim. It became the best selling book Joint Publishing Company in Hong Kong had ever published. The following year the English translation, *Classic Chinese Furniture*, was published, closely followed by French and German editions.

The excitement generated by these events created huge interest in Ming furniture. The marketplace responded to this new level of awareness, and by 1986 local dealers and their counterparts in China were collaborating in the search for Ming furniture. In time these activities were to include not only Beijing, Tianjin, and the province of Shanxi but also the coastal provinces of Jiangsu, Zhejiang, and Fujian, as well as Anhui and Jiangxi.

At this time, I set up my business to specialize in Ming furniture, the first in Hong Kong. From a modest first floor warehouse in Hollywood Road, it quickly progressed to include a showroom in Central, the business and financial district of Hong Kong. Our workshop of three carpenters (I was the polisher, the skill learned from my apprentice days in a restoration workshop in England) was kept busy by the first waves of purchases from oriental art dealers from Europe and America, many of whom I had been a client of in my collecting days. Then came the local tycoons and many from Hong Kong's community of collectors of Chinese art.

In April 1988, two significant events occurred that were to profoundly affect the study and collection of Ming furniture. Dr S. Y. Yip of Hong Kong and the Fellowship of Friends, based in California, entered the market.

Dr S. Y. Yip, eminent dermatologist, collector of Chinese paintings and calligraphy, president emeritus of the influential and select collectors' group, the Min Chiu Society, began to collect Ming furniture in 1988. He was to build an impressive and representative collection that surpassed all other known private collections. A selection from his holdings went on exhibition at the Art Gallery of the Chinese University of Hong Kong in September 1991. The accompanying catalogue, *Dreams of Chu Tan Chamber and the Romance with Huanghuali Wood: The Dr S. Y. Yip Collection of Classic Chinese Furniture*, was the first catalogue to be published on any private collection of Ming furniture.

The Dr S. Y. Yip Symposium on Classic Chinese Furniture, held in Hong Kong at the same time as the exhibition, brought together a forum of scholars from China, Hong Kong, Europe, and America, and the papers delivered were published in a special January 1992 issue of the oriental art magazine *Orientations*.

The Fellowship of Friends, a non-denominational organization, owners of the Renaissance Vineyard and Winery, first added Ming furniture to their fine art collection in 1988. They were to continue to collect Ming furniture with dedication and established the Museum of Classical Chinese Furniture, the first in the world devoted to the collection and preservation of Chinese hardwood furniture from the Ming and early Qing dynasties. In 1990 they formed the Classical Chinese Furniture Society. They started to publish quarterly journals in 1991 to encourage the study and appreciation of Chinese hardwood furniture.

Meanwhile in Beijing, the Association of Chinese Classical Furniture was established in 1989, its members comprising scholars and collectors including Wang Shixiang and Zhu Jiajin, whose father had been a prominent collector of Chinese art and furniture. Quarterly journals were published in Chinese.

Ming furniture has come into its own among both collectors and scholars. Many antique shops in Hong Kong display Ming or Ming-style furniture, and new businesses have been set up to promote their sale.

In 1989 and 1990, the two-volume *Mingshi Jiaju Yanjiu* (Connoisseurship of classic Chinese furniture) by Wang Shixiang was published in Chinese and English. This definitive work on classic Chinese furniture was the result of Wang's more than forty years of meticulous research on a wide variety of classic pieces. The American lecture tour Wang undertook to launch the book further promoted interest in the field.

With interest in Ming furniture at an all-time high, it was hardly surprising that another symposium was held in Beijing in November 1991, this time in honour of the memory of Gustav Ecke, followed by another in Suzhou the following year. A sales exhibition in Hong Kong was devoted exclusively to Ming furniture, and another symposium in San Francisco in the autumn of 1992 was organized by the San Francisco Craft and Folk Art Museum. In addition, many scholarly writings have since been published on the subject.

When the Hong Kong Museum of Art moved to its new premises in November 1991, Ming furniture was included in its collection. The private Tsui Museum of Art added a room of *huanghuali* furniture when it moved from Kowloon to Hong Kong in September 1992. However, the full impact of the events of the 1980s and 1990s will only be revealed when the sum total of the private collections formed in Hong Kong, Taiwan, Singapore, and the rest of the world during these two decades is made public.

Chronological Table

Shang	*c.*1550–1027 BC
Western Zhou	1027–771 BC
Eastern Zhou	
Spring and Autumn period	770–475 BC
Warring States period	475–221 BC
Qin	221–207 BC
Western Han	206 BC–AD 9
Wang Mang	9–25
Eastern Han	25–220
Period of Disunity	221–581
Sui	581–618
Tang	618–907
Five Dynasties	907–960
Song	960–1279
Jin	1115–1234
Yuan (Mongol)	1271–1368
Ming	1368–1644
Hongwu reign	1368–1398
Jianwen reign	1398–1402
Yongle reign	1402–1424
Hongxi reign	1424–1425
Xuande reign	1425–1435
Zhengtong reign	1435–1449
Jingtai reign	1449–1457
Tianshun reign	1457–1464
Chenghua reign	1464–1487
Hongzhi reign	1487–1505
Zhengde reign	1505–1521
Jiajing reign	1521–1567
Longqing reign	1567–1572
Wanli reign	1572–1620

Taichang reign	1620
Tianqi reign	1620–1627
Chongzhen reign	1627–1644
Qing	1644–1911
Republic of China	1912–1949
People's Republic of China	1949–

Glossary

an 案	table with legs recessed from the corners
baimu 柏木	wood perhaps taken from a variety of cypress
baitong 白銅	white metal alloy used for fittings
bawangcheng 霸王棖	S-shaped brace
chihulong 螭虎龍	playful hornless dragons, a motif in furniture decoration
dalishi 大理石	marble from Dali, in Yunnan province
deng 櫈	any of a number of styles of Ming stools
dengguayi 燈掛椅	yoke-back side chairs
fangjiao gui 方角櫃	square-cornered cabinets
hongmu 紅木	South-east Asian rosewood, first used as material for furniture in the late Qing dynasty
huanghuali 黃花梨	fine tropical hardwood varying in colour from pale honey to dark purple brown (also termed huali 花梨 or hualü 花櫚)
huangtong 黃銅	yellow brass, sometimes used for fittings
huangyangmu 黃楊木	boxwood
huchuang 胡牀	'barbarian bed', a folding stool which first appeared during the Western Han dynasty
jiage 架格	bookshelf
jiaowu 交杌	folding stool similar to the *huchuang*
jiazichuang 架子牀	canopied bed
jichimu 雞翅木	hardwood with lines of purple and yellow
juancaowen 卷草紋	scrolling tendrils, used as a motif in furniture decoration
jumu 椐木	zelkova, wood from a variety of Asian elm
kang 炕	hollow brick platform used as a living space in Chinese houses, can be heated during the winter months
kangji 炕几	low table used on the *kang*
kangzhuo 炕桌	low table used on the *kang*

luohanchuang 羅漢牀	literally 'monk's bed', a couch bed
luoguocheng 羅鍋棖	hump-back shaped stretcher
mati 馬蹄	hoof-shaped feet
meiguiyi 玫瑰椅	'rose chair', a type of armchair
mianpenjia 面盆架	basin stand
nanguanmaoyi 南官帽椅	continuous yoke-back armchair
nanmu 楠木	wood perhaps taken from a variety of cedar
pingtouan 平頭案	*an* table with flat ends
qiaotouan 翹頭案	*an* table with everted ends
quanyi 圈椅	horseshoe armchair
sanwantui 三彎腿	'three-bended leg', a cabriole leg
shuyao 束腰	waist or inset panel between top and apron
sichutou guanmaoyi 四出頭官帽椅	yoke-back armchair
sijian gui 四件櫃	four-piece cabinet
ta 榻	sometimes translated as 'daybed', a low platform-like seat first appearing during the Han dynasty
tianranji 天然几	naturalistic tables or stands
tieli 鐵力	hardwood resembling *jichimu* but coarser and more open in grain
wan 萬	character for 'ten thousand', used as a motif in furniture decoration
wumu 烏木	ebony
xiangji 香几	incense stand
yijia 衣架	clothes-rack stand
yuanjiao gui 圓角櫃	'round-cornered cabinet'—the sloping-stile, wood-hinged cabinet prominent in Ming furniture
zhedieshi tangyi 叠折式躺椅	folding reclining chair
zhuo 桌	table with legs at the four corners
zitan 紫檀	closely grained hardwood varying in colour from reddish-brown to purple-black

Selected Bibliography

Beurdeley, Michel, *Chinese Furniture*, Katherine Watson, trans. Tokyo and New York: Kodansha International, 1979.

Bruce, Grace Wu, *Dreams of Chu Tan Chamber and the Romance with Huanghuali Wood: The Dr S. Y. Yip Collection of Classic Chinese Furniture*, Hong Kong, 1991.

Clunas, Craig, *Chinese Furniture*, London: Victoria and Albert Museum, 1988.

Ecke, Gustav, *Chinese Domestic Furniture*, Peking: Henri Vetch, 1944. Reprinted by Charles E. Tuttle: Rutland, Vermont and Tokyo, 1962.

Ellsworth, Robert Hatfield, *Chinese Furniture: Hardwood Examples of the Ming and Early Ching Dynasties*, New York: Random House, 1971.

——, *Chinese Hardwood Furniture in Hawaiian Collections*, Honolulu: Honolulu Academy of Art, 1982.

Kates, George N., *Chinese Household Furniture*, New York and London: Harper and Brothers, 1948. Reprinted by Dover Publications: New York, 1962.

Lin Shoujin, *Zhanguo Ximugong Sun jiehe gongyi yanjiu* [Research on joinery in the Warring States period], Hong Kong: Zhongwen daixue chubanshe, 1981.

Ruitenbeek, Klaas, *Carpentry and Building in Late Imperial China, A study of the fifteenth-century carpenter's manual Lu Ban Jing*, Leiden, New York, and Koln: E. J. Brill, 1993.

Sickman, Laurence, 'Chinese Classic Furniture: A lecture given by Laurence Sickman on the occasion of the third presentation of the Hills Gold Medal', London: The Oriental Ceramic Society, 1978.

Wang Shixiang, *Classic Chinese Furniture—Ming and Early Qing Dynasties*, London, Han-Shan Tang, 1986. Originally

published in Chinese as *Mingshi jiaju zhenshang*, Joint Publishing (HK) Co, 1985.

——, *Connoisseurship of Chinese Furniture: Ming and Early Qing Dynasties*, 2 vols., Hong Kong: Joint Publishing (HK) Co, 1990. Originally published as *Mingshi jiaju yanjiu*, 2 vols., 1989.

Other works cited

An Jinhuai and Wang Yugang, *Mixian Dahuting Handai huaxiang shimu he bihua mu* [Han dynasty tomb with engraved stone and wall paintings at Mixian, Dahuting], *Wenwu*, 10 (1972): 49–62.

Cescinsky, Herbert, *Chinese Furniture*, London: Benn Brothers, 1922.

Chen Rong, *Zhongguo shumu fenlei xue* [Classification of Chinese woods], Shanghai: Science and Technology Press, new edition 1, December 1959.

Chen Zhi, *Zhangwu zhi jiao zhu* [Explanatory notes on Wen Zhenheng's Treatise on superfluous things], Jiangsu: Jiangsu kexue jishu chubanshe, 1984.

Fan Lian, *Yunjian jumuchao* [Records of events in Yunjian], *Biji xiaoshuo daguan*, Republic edition.

Fu Xihua, *Zhongguo gudian wenxue banhua xuanji* [Selected woodblock illustrations of classic Chinese literature], 2 vols., Shanghai: Renmin meishu chubanshe, 1978.

Henan sheng wenhuaju, *Woguo Kaogushi shang de kongqian faxian Xinyang Changtai guan fajue yi zuo Zhanguo da mu* [Our country's major discovery in achaeology—a large Warring States tomb in Xinyang, Changtai guan], *Wenwu Cankao Ziliao*, 9 (1957): 21–5.

Hubei Sheng wenhuaju, *Hubei Jiangling sanzuo Chu mu chutu dapi zhong yao wenwu* [Important finds from three Chu tombs at Jiangling, Hubei], *Wenwu*, 5 (1966): 33–41.

Jin Ping Mei Cihua [The golden lotus], photocopy edition, text after Wanli edition, illustration after Chongzhen edi-

tion, 21 vols., Beijing: Wenxue guji kanhangshe.

Liu Ruoyu, *Zhuo zhong zhi* [Records of life in the administrations], *Congshu jicheng chuban*, edited by Wang Yunwu, Shanghai: Shangwu yinshuguan, 1937.

Qiu Ying, *Chinese Gardens on Paper and Silk* [Yuan lin minghua tezhan tulu], Taipei: National Palace Museum, 1987.

Roche, Odilon, *Les Meubles de la Chine*, Paris: Librairie des Arts Decoratifs, 1921.

Tian shui bing shan lu [Records of the Waters of Heaven and Ice Mountains], *Congshu jicheng chuban*, edited by Wang Yunwu (based on *Zhibuzu zhai congshu*), 3 vols., Shanghai: Shangwu yinshuguan, 1937.

Wang Shixing, *Guang zhi yi* [Records on a wide variety of topics], Taizhou congshu, Jiaqing edition.

Wang Siyi, *Sancai Tuhui* [The Late Ming pictorial encyclopedia], 3 vols., Shanghai: Shanghai guji chubanshe, 1958.

Wu Xuqing et al., *Jingmen Baoshan erhao mu bufen yiwu de qingli yu fuyuan* [A partial site and restoration report of tomb no. 2 at Baoshan, Jingmen], *Wenwu*, 5 (1988): 15–24.

Zheng Zhenduo, *Zhongguo banhua shi tulu* [An Illustrated history of Chinese woodcuts], 20 vols., Shanghai: Zhongguo banhua shishe, 1940.

———, *Zhongguo banhua xuan* [Selected Chinese wood-cuts], 2 vols., Beijing: Rongbaozhai, 1958.

———, *Zhongguo gudai banhua congkan* [Ancient Chinese wood-cuts], 4 vols., Shanghai: Shanghai guji chubanshe, 1988.

Index

CHINA

XINJIANG UYGUR
Autonomous Region

QINGHAI

TIBET
Autonomous Region